INSTANT

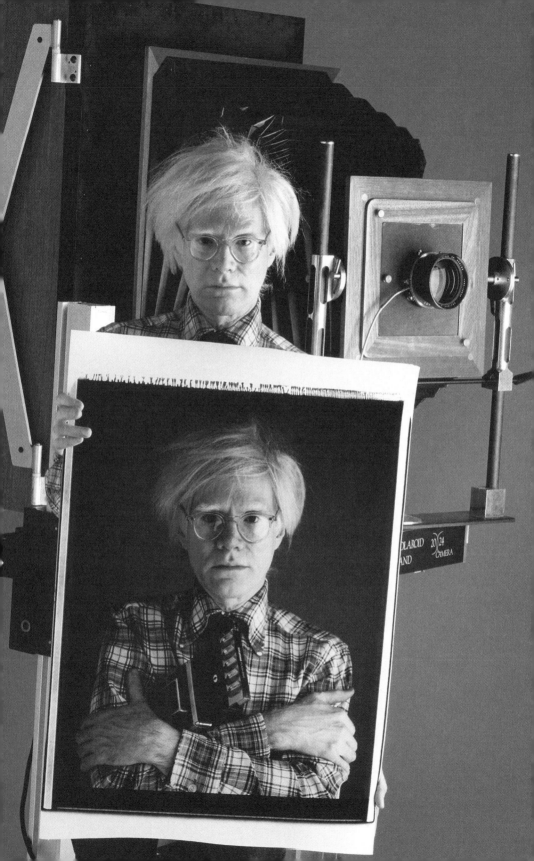

INSTANT
THE STORY
OF
POLAROID

Christopher Bonanos

Princeton Architectural Press, New York

For Ellen
love without fading

Published by
Princeton Architectural Press
37 East Seventh Street
New York, New York 10003
Visit our website at www.papress.com

Printed in the United States by Courier
15 14 13 4 3

Polaroid is a trademark of PLR IP Holdings,
LLC, used with permission.

FRONTISPIECE: In 1980 Andy Warhol
posed before the 20x24-inch Polaroid camera,
a moment after he was photographed with his
(much smaller) SX-70 tucked under his arm.

Editor: Dan Simon
Design: The Graphics Office

Special thanks to:
Bree Anne Apperley, Sara Bader,
Janet Behning, Nicola Bednarek Brower,
Fannie Bushin, Megan Carey, Carina Cha,
Andrea Chlad, Russell Fernandez,
Will Foster, Jan Haux, Diane Levinson,
Jennifer Lippert, Gina Morrow,
Katharine Myers, Margaret Rogalski,
Elana Schlenker, Andrew Stepanian,
Paul Wagner, and Joseph Weston of
Princeton Architectural Press
—Kevin C. Lippert, publisher

Library of Congress
Cataloging-in-Publication Data
Bonanos, Christopher, 1969–
Instant: the story of Polaroid / Christopher
Bonanos.
p. cm.
ISBN 978-1-61689-085-8 (hardback)
1. Polaroid Corporation. 2. Photographic
industry—United States—History.
3. Photographic film industry—
United States—History. 4. Camera
industry—United States—History. I. Title.
HD9708.U64P653 2012
338.7'6814180973—dc23
 2012011514

Digital edition ISBN: 978-1-61689-158-9

Contents

A GENIUS AND HIS

LIFE

MAGIC CAMERA

Dr. Edwin Land of Polaroid
demonstrates his
new invention

OCTOBER 27 · 1972 · 50¢

Edwin Land makes the cover of *Life*—
without showing his face.

1 Light and Vision

If you're reading this, you probably know what a Polaroid picture is. Even if you weren't, I probably wouldn't have to tell you. More than sixty years after instant photography made its debut, "Polaroid" remains one of the most recognizable coinages on Earth. As late as 2003, the hip-hop star Andre 3000 could sing "Shake it like a Polaroid picture," in Outkast's megahit "Hey Ya," and even young people did not have to ask what he meant.[1] Throughout its reign over instant photography—a field the company invented out of thin air and built into a $2-billion-a-year business—Polaroid had no successful competitor, no real challenge to its primacy, until almost its very end.

In the 1970s, photographers were shooting a billion Polaroid photographs each year. Now the whole business has almost vanished. Right around the year 2000, picture-taking experienced a tidal change, as digital cameras swept in and all but cornered the market. Suddenly, photographic film became a specialty item, bought chiefly by artists. Any company that depended on selling or processing film had to endure some rough years of realignment. Eastman Kodak went from its late-1980s peak of 145,000 employees to fewer than 20,000, and filed for Chapter 11 protection in 2012. Polaroid, already struggling with longstanding debt and other problems, got clobbered. Between 2001 and 2009 the company declared bankruptcy twice and was sold three times; one of those buyers went to federal prison for fraud. Polaroid film was discontinued forever in 2008.

Except that it's not exactly gone. A few types of instant film are still manufactured by Fujifilm, for some older Polaroid cameras and current Fuji models. The last batches of Polaroid's own film have become highly

1 For the record, you shouldn't shake your Polaroid pictures. They don't develop any faster when you do, and you risk cracking the image. Most people shake them anyway. See chapter 3 to find out why.

sought after, with buyers paying $40 or $50, or even more, for a pack of ten expired and increasingly unreliable exposures. A few enthusiasts have taken their analog-revival efforts to great lengths, trying to reinvent instant film anew. The newest owners of the Polaroid trademark have elaborate plans to meld instant photography with the digital age.

After all, digital pictures *are* instant pictures. The chief advance of Polaroid photography was that you immediately saw what you had done. If the photo was overexposed, blurry, or badly framed, you could try shooting it again, then and there. With a digital camera, you get your feedback even faster, essentially for free.

Somehow, though, digital pictures do not draw people together the way Polaroid photos did. Haul one of those old cameras out at a party, and the questions start: "Hey—can you still get film for that thing?" "Are the cameras worth money?" And, once the photos start appearing, "You know, that looks pretty good! I don't remember Polaroids looking like that. But, you know, we had one when I was little, and...." This gee-whiz invention of the 1940s, ubiquitous in the 1970s, ostensibly obsolete today, still exerts a weird and bewitching pull.

It wasn't just for snapshots, either. During Polaroid photography's heyday, artists like Ansel Adams and Walker Evans sang its praises. Andy Warhol, David Hockney, and Robert Mapplethorpe all shot thousands of Polaroid pictures. Most of William Wegman's famous photos of his dogs were taken on Polaroid film. He and many other artists, including Chuck Close and Mary Ellen Mark, were (and are) particularly fond of an immense and very special Polaroid camera that produces prints 20 inches wide and 24 inches high. Fewer than a dozen of these cameras were hand-built by Polaroid; five remain active; and one, in New York, is in use almost every day. No digital equipment comes even remotely close to doing what it does.

Children, in particular, react very strongly to instant pictures, whether they're behind the camera or in front of it. Watching your own face slowly appear out of the green-gray mist of developing chemicals is a peculiar and captivating experience. The older Polaroid materials, those that develop in a little paper sandwich that is peeled apart after a few moments' development, encourage a different and warm human

Walker Evans had stopped
making photographs when SX-70
came along and allowed him
a late-career burst of creativity.

Evans used the small square format to document Americana: signage, peeling paint, or a crushed beer can in a stream.

exchange. Photographer and subject can make small talk as the picture steeps. When the print is revealed, it can be handed over as a gift or circulated around the room. There is no more social form of picture-taking.

When it introduced instant photography in the late 1940s, Polaroid the corporation followed a path that has since become familiar in Silicon Valley: Tech-genius founder has a fantastic idea and finds like-minded colleagues to develop it; they pull a ridiculous number of all-nighters to do so, with as much passion for the problem-solving as for the product; venture capital and smart marketing follows; everyone gets rich, but not for the sake of getting rich. For a while, the possibilities seem limitless. Then, sometimes, the MBAs come in and mess things up, or the creators find themselves in over their heads as businesspeople, and the story ends with an unpleasant thud.

The most obvious parallel is to Apple Computer, except that Apple's story, so far, has a much happier ending. Both companies specialized in relentless, obsessive refinement of their technologies. Both were established close to great research universities to attract talent (Polaroid was in Cambridge, Massachusetts, where it drew from Harvard and MIT; Apple has Stanford and Berkeley nearby). Both fetishized superior, elegant, covetable product design. And both companies exploded in size and wealth under an in-house visionary-godhead-inventor-genius. At Apple, that man was Steve Jobs. At Polaroid, the *genius domus* was Edwin Herbert Land.

Just as Apple stories almost all lead back to Jobs, Polaroid lore always seems to focus on Land. In his time, he was as public a figure as Jobs was. At Kodak, executives habitually referred to Polaroid as "he," as in "What's *he* doing next?" Land and his company were, for more than four decades, indivisible. When he introduced its SX-70 system in 1972— that's the photo with the wide white border that most of us think of as the classic Polaroid picture—Land appeared on the covers of both *Time* and *Life* magazines.

At Polaroid's annual shareholders' meetings, Land often got up onstage, deploying every bit of his considerable magnetism, and put the company's next big thing through its paces, sometimes backed by a slideshow to fill in the details, other times with live music between segments.

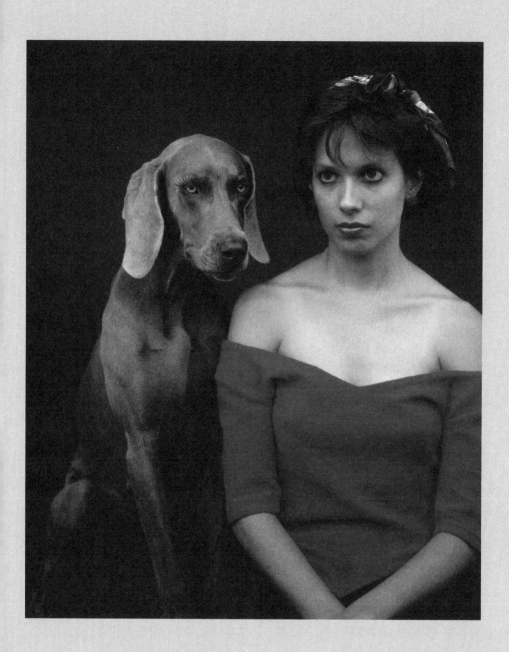

ABOVE: **One of William Wegman's Weimaraners in a polite Polaroid moment with studio assistant Andrea Beeman.**

OPPOSITE: **Robert Mapplethorpe not only used Polaroid film; for this tableau of photos of his lover and muse Patti Smith, he also incorporated the empty film cartridges (painted white) and one of the darkslides (reading "Don't Touch Here") that covered each new pack.**

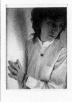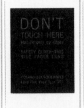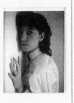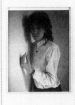

A generation later, Jobs did the same thing, in a black turtleneck and jeans. Both men were college dropouts; both became as rich as anyone could ever wish to be; and both insisted that their inventions would change the fundamental nature of human interaction.

Jobs, more than once, expressed his deep admiration for Edwin Land. In an interview in *Playboy*, he called him "a national treasure." After Land, late in his career, was semi-coaxed into retirement by Polaroid's board, Jobs called the decision "one of the dumbest things I've ever heard of." In fact, the two men met three times when Apple was on the rise, and according to Jobs's then-boss John Sculley, the two inventors described to each other a singular experience: Each had imagined a perfect new product, whole, already manufactured and sitting before him, and then spent years prodding executives, engineers, and factories to create it with as few compromises as possible.

During some stretches, Polaroid operated almost like a scientific think tank that happened to regularly pop out a profitable consumer product. Land was frequently criticized by Wall Street analysts, and the *Wall Street Journal* in particular, for spending a little too much on his R&D operation and too little on practical matters. That was Land's philosophy: Do some interesting science that is all your own, and if it is, in his words, "manifestly important and nearly impossible," it will be fulfilling, and maybe even a way to get rich. In his lifetime, Land received 535 United States patents.[2] No wonder everyone called this college dropout "Dr. Land"—particularly after Harvard University gave him an honorary doctorate. He advised several presidents (from Eisenhower through Nixon) on technology, and effectively created the U-2 spy plane. Richard Nixon admired his scientific prowess, once asking an aide, "How do we get more Dr. Lands?"

2 Just about every biographical sketch of Land notes that this total is second only to Thomas Edison's, and every one is wrong. As Dr. Deborah Douglas, curator of the MIT Museum, points out, the number-two patent-holder was Elihu Thomson, an early force at General Electric. In recent years, several inventors have vastly surpassed Edison's total.

After he quit his advisory post during the Watergate scandal, Land ended up on Nixon's "enemies list," and told a friend that he was honored to have made the cut.

He was extremely circumspect about his family life, but we know a little about his upbringing. He was born on May 7, 1909, the son of a scrap-metal dealer named Harry Land and his wife, who was called Matha, Matie, or Martha, depending on which source you read.[3] As a child, Land had trouble pronouncing "Edwin," and it came out "Din," a nickname that stuck with him all his life.

Nearly every account of Land's youth conforms to the classic boy-inventor clichés. Did he once blow all the fuses in his parents' house? Of course, when he was 6 years old. Did he once disassemble a significant household object, resulting in either parental anger or parental pride? Certainly—either the family's brand-new gramophone or the mantel clock. Whatever it was, his father was not amused.

He was, it seems, introverted in person but superbly confident when it came to ideas. Accustomed as we are today to Silicon Valley style, this may imply that he was a big nerd, but that's not right. Land was neatly groomed and notably handsome, with a pleasing, New England–inflected baritone voice, and alongside his scientific passions lay knowledge of art, music, and literature. He was a cultured person, growing even more so as he got older, and his interests filtered into the ethos of Polaroid. His company took powerful pride in its relationship to fine artists, its sponsorship of public television, even its superior graphic design. He liked people who had breadth as well as depth—chemists who were also musicians, say, or photographers who understood physics. He took very good pictures, too.

As a young adult, Land grew close to Clarence Kennedy, an art-history professor at Smith College who was also a fine photographer. Their rela-tionship not only helped refine Land's eye but also began to feed Polaroid with brainy, aesthetically inclined Smith graduates, handpicked and recommended by Kennedy. It was a clever end run around the competi-tion for talent, because few corporations were hiring female scientists, and even fewer were looking for them in Smith's art-history department.

3 Two books are the indispensible starting point for any serious reading about Polaroid. Victor McElheny's biography of Land, *Insisting on the Impossible* (Perseus Books, 1998), is spectacularly thorough, a serious piece of scholarship that displays its author's long-term research and deep immersion in Polaroidiana. The Polaroid executive Peter Wensberg's memoir, titled *Land's Polaroid* (Houghton Mifflin, 1987), is more narrative and personal, and is long out of print. I have drawn on both, and am indebted to McElheny's book in particular, as well as to the author himself, for the sketch of Land's early life in this chapter, and for the general timeline of the Polaroid story.

Sometimes he sent the young women off for a couple of semesters' worth of science classes, manufacturing skilled chemists who could keep up when the conversation turned from Maxwell's equations to Renoir's brush strokes. In-house, people called them the Princesses.

Land was also extraordinarily tenacious. One of his top research executives, Sheldon Buckler, recalls a story Land told him during a long night in the lab. As a child, Land had been forced to visit an aunt he disliked. As he sat in the backseat of his parents' car, he set his jaw and told himself, "I will never let anyone tell me what to do, ever again." You could write that off as youthful mulishness, except that it turned out to be true. Land's control over his company was nearly absolute, and he exercised it to a degree that was compelling and sometimes exhausting.

He didn't grow up in a particularly intellectual household. Land once remarked disdainfully that there were virtually no books in his childhood home. Somehow, though, he found himself a copy of the 1911 edition of *Physical Optics,* a textbook by the physicist Robert W. Wood, and obsessed over its contents the way other kids might have memorized baseball statistics—lingering on one particular chapter, about the polarization of light.

A polarizer is a unique type of filter, and its properties are best explained with an oversimplification that Land himself often used. Waves of light, as they come at you, vibrate in every plane, vertically, horizontally, and at all angles in between. Certain crystal structures can function as gratings, allowing through light that vibrates in just one plane. If you picture the beam of light as a handful of thrown straws, oriented in every direction, the polarizing filter is a picket fence. The only straws that come through are the ones that align with the slots between pickets. Sunlight is also polarized when it bounces off a flat, nonmetallic surface, like a lake or the roadway in front of you, causing glare. Adding a polarizing layer to sunglasses blocks light vibrating in that one plane, wiping out the glare and helping drivers see the road or fishermen spot trout beneath the surface of a stream. Photographers, too, use polarizing filters to even out lighting.

The real versatility appears when you put a pair of these filters together. Shine a light through that picket fence, and its waves align. Now

How Polarizers Work

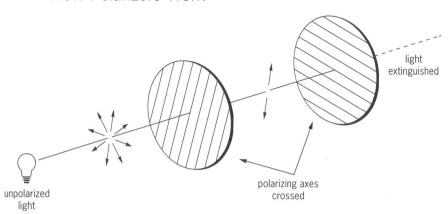

light
extinguished

unpolarized
light

polarizing axes
crossed

Land's attempt to sell polarized headlights and windshields did not lead to a deal with Detroit, but it did create a lot of prototypes—and lawsuits. The tag on this one carries notations from both Polaroid's corporate museum and a patent-infringement case.

put a second fence in front of the first. If the two sets of slots line up, light keeps on going through; if the slots of the second filter are turned at right angles to the first, the light is blocked. If you have the ability to pivot the second filter back and forth, you've made a finely controlled, variable valve. Whether in your laptop screen, your flat TV, or your LCD digital clock, every pixel is lightened and darkened this way.

Polarizers exist in nature too. A Nicol prism—a clear calcite crystal cut at a precise angle, then reassembled—can do the job. So can a tourmaline gem. There's also an artificially produced crystal called herapathite, named for its discoverer, William Herapath. All are very small and expensive, of extremely limited utility. If you want a big, flat polarizing filter—one large enough to make a pair of sunglasses, say—they won't work. Herapathite crystals are like tiny needles, and Herapath spent a long frustrating time trying to grow larger ones.

Land, already steeped in optics from Wood's book, had seen a Nicol prism during a scientific demonstration at summer camp. When he went off to Harvard in 1926, he was still thinking about polarizers and what they could do. A year later, he had temporarily withdrawn, frustrated by the rigidity of the classroom and his unserious classmates. He moved to New York City, where he rented a small room and turned it into a lab.

At first, he, like Herapath, tried to grow big crystals, and soon discovered that he couldn't. His innovation, one that a few people had tried before him without success, was the idea that millions of submicroscopic crystals, lined up somehow, might do the same work, and if you could coax these onto a clear sheet, you'd have your filter. Land threw himself into this problem like a man possessed. He'd gotten married during these years, to a woman named Helen Maislen. Known as Terre (pronounced "Terry"), she too had some scientific training and regularly joined him in the laboratory. In order to use specialized equipment, Land used to sneak into a locked lab at Columbia University late at night, climbing out onto the window ledge to get in.

It was in 1928 when Land, aged just 19, first broke through. His first synthetic polarizer—the world's first, a genuinely major scientific discovery—was a vial of fluid filled with tiny floating crystals aligned

with a big magnet. Soon after, he figured out how to coat a thin plastic sheet with a wet layer of microscopic crystals, then align them by stretching the sheet before the whole thing dried. It was a unique, commercializable, salable product, and Land rapidly linked up with two people to guide him in the business world: Donald Brown, a patent lawyer, and Julius Silver, a dour and effective attorney who'd been his summer-camp counselor a few years earlier. Silver, in particular, became a guiding figure throughout Land's entire life, coaching him on anything of financial or legal significance, and remaining on Polaroid's board till he was 87 years old.

Patents became a near fetish with Land. His first, for the sheet polarizer, was dated April 26, 1929, and he knew how he was going to try to commercialize it. As he recounted it in later years, he had been walking in Times Square one night, and was repeatedly blinded by oncoming cars' lights. Soon enough, he'd figured out a solution: Put polarizers with horizontal slits across each headlight, and polarizers with vertical slits over each car's windshield. For drivers so equipped, oncoming headlights would be nearly blacked out while their own would continue to illuminate the road normally. It's a pretty great idea, and nobody has offered a better solution, even eighty years later.

You may be noticing, by the way, that none of this has anything to do with instant photography. Polarizers rather than pictures would define the first two decades of Land's intellectual life, and would establish his company and career. Instant photos were an idea that came later on, a secondary business around which his company was completely re-created.

By this time, Land had returned to Harvard, falling in with his physics instructor, a recent graduate named George W. Wheelwright III. Wheelwright was an archetypal product of the old New England upper crust, freed by family wealth to explore whatever parts of life interested him. He'd worked aboard a freighter after graduation, then gone back to Harvard to teach, and was so impressed with Land that he wangled him some lab space. Within a year or so, he and Land were talking about going into business. Land had a little capital from his father, plus his polarizer patent; Wheelwright had the rest. In 1932, Land became a permanent

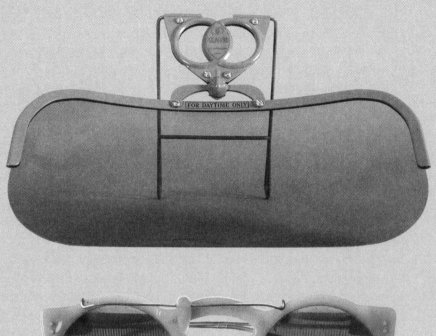

TOP: **A consolation prize: Polaroid didn't get to cover every headlight and windshield in America, but it did market a glare-reducing visor that any driver could install.**

BOTTOM: **Polaroid sunglasses were the company's one early moneymaker. These, called Variable Day Glasses, were adjustable. Slide the little switch along the bridge, and it darkens or lightens the lenses.**

Harvard dropout, and Land-Wheelwright Laboratories was in business. A chalkboard in their little lab read EVERY NIGHT 50 PEOPLE WILL DIE FROM HIGHWAY GLARE. Land wanted to make sure everyone there understood that they were all on a mission. Manifestly important.

There were already competing polarized-headlight ideas on the market, but they lacked Land's key ingredient: the thin-sheet polarizer. He and Wheelwright aggressively pitched their system to the auto companies while working nonstop to refine and produce their new material in quantity. The staff logged overtime and nights, missing dinners and spending weekends in the lab. Land once worked eighteen days straight without going home to change his clothes, and two of those days were Christmas and New Year's.

He all but admitted that his scientific work was his first priority. "If you dream of something worth doing and then simply go to work on it," he once said, "and don't think anything of personalities, or emotional conflicts, or of money, or of family distractions; if you just think of, detail by detail, what you have to do next, it is a wonderful dream." Though by all accounts he and Terre had a fine marriage, one that lasted sixty-one years, she could certainly get frustrated at his absence and his distractedness. One of his employees recalls accompanying him, later in life, on a night when he picked her up at Logan airport quite a bit later than he'd said he would. As they arrived, Terre shouted, "You're always late, you've always been late, even when Jennifer [their daughter] graduated," and kept giving him a hard time, all the way back to their home in Cambridge. Land didn't say a word—and, after dropping her off at the house, he went back to the office.

Everyone who worked for Land seems to have a memory of the man's intense workdays, whether in these early years or decades later. The people who were close to him grew accustomed to 4 A.M. phone calls, along the lines of, "I had an idea about that problem we've been working on. Would you come in and meet me at five?" Some grew weary of it. Stan Calderwood, who ran Polaroid's marketing and sales operation for many years, got those calls regularly, until one night when his exasperated wife answered the phone and exploded at the boss.

Others found the experience invigorating. Sarah Hollis Perry, one of the Princesses, worked closely with Land for more than thirty years, nearly to the end of his life, and had a dedicated telephone line installed in her house. "When the red phone rang," she recalls, "I'd look around to see if my children were killing themselves, and if not, I'd pick it up." These presidential calls rarely began with small talk. "He'd say 'Tell me something interesting.' And you'd think and say something, and then there would be a two-minute pause—long, long times, when he was thinking—and eventually he'd come back into the conversation. You never felt the need to keep a conversation moving. He just had a tremendously confident way of talking on the telephone, knowing that you weren't going to hang up. You had to be patient. He was demanding, very demanding, but he was so brilliant that it was remarkable."

Land-Wheelwright needed a major contract to provide stability and cash flow, and its best hope lay with Eastman Kodak, the largest photographic company in the world. Its founder, George Eastman, had in 1888 introduced the first camera loaded with dry film, to be mailed in for processing and returned with prints and a fresh roll. The Kodak camera had turned picture-taking into a mass phenomenon. Glass negatives, the black drape over the photographer's head, a darkroom full of fumes—all the things that made photography a specialist's business were eliminated. Eastman's little black box was marketed with the slogan "You push the button, we do the rest," and the little roll of celluloid inside it built an empire, especially after the movie business began to buy billions of miles of footage. And polarizing filters, for all sorts of photographic and industrial uses, were of great interest to Kodak.

Victor McElheny's biography of Land, *Insisting on the Impossible,* lays out the delicate and elaborate multiyear dance between Polaroid and Kodak, which I need not recap here. Suffice it to say that Kodak was a little apprehensive about the two entrepreneurs' youth but interested enough to sign a deal. Land-Wheelwright's staff immediately went into crash mode, coaxing batches of polarizing sheet out of the balky machinery they'd built. At the end of 1934, the first parcel went off to Eastman in Rochester, New York, and $5,000 came back. It wasn't their first sale—that had been to Bell Laboratories, the previous August, for $250—but

it was the big one. Contracts followed with American Optical (to make sunglasses) and Bausch & Lomb.

Much of the outside interest in Land's company came from the headlight project. He pushed it relentlessly, urgently, insisting that he could save thousands of lives per year. He got so much press, in fact, that in 1936 a news-clipping service pitched itself to Land-Wheelwright, offering a special rate for high volume. Though he faced some technical problems (especially making a polarizer that could stand up to the heat of a headlight bulb), the real problem was corporate. General Motors, Ford, and the other automakers of the day were willing to talk to Land, but nobody wanted to take the lead. They seem to have had a vague suspicion of this outsider's idea. Also, every car on the road would've had to be equipped to make the system work, so the carmaker that went first would have no sales advantage.

How Land-Wheelwright got all that public attention was no mystery. Over and over, when faced with scientific illiteracy or lack of imagination, Land resorted to a restrained bit of showbiz. As it turned out, he was strikingly good at explaining his work to people, and powerfully persuasive. Even the simple act of rotating one polarizer over another, whereupon two nearly clear sheets gradually turn black, had (and still has) the quality of a small magic trick. When Land pitched polarizing sunglasses to American Optical, he didn't just show up with a few samples. He rented a Boston hotel room facing the sun and checked in with a bowl of goldfish, which went on the windowsill, refracting glare into the room. The AO executives arrived at the door, whereupon Land mock-apologized for the glare, saying "you probably can't even see the fish," and handed each man a filter. He closed the deal.

His physical presence helped, too. "Dr. Land's eyes were something to be experienced," recalls Nan Rudolph, a chemist who worked in his lab in the late 1950s. (She had been yet another of Clarence Kennedy's Smith College students.) "When he looked at you, it was the most piercing look you'd ever seen. I think that's what people deferred to—that analytical, intelligent, piercing gaze." Many old Polaroidians recall that look, especially the ones who were young then, people who couldn't believe that the great inventor was bringing his focus to them.

Land could write, too. As Polaroid grew, his letter to shareholders, published in the annual report, gradually became a particularly dramatic showcase for his language and his thinking. These letters—really more like personal mission statements—are thoughtful and compact, and just eccentric enough to be completely engaging. Instead of discussing earnings and growth, they laid out Land's World, inviting everyone to join.[4] They are an astonishing departure from the baggy corporate-speak of most annual reports. He cared about words nearly as much as he did about scientific rigor: When he elevated the marketing executive Ted Voss to become a corporate officer, Land gave him a four-word job description: "Keeper of the language."

Land's first real bit of linguistic innovation appeared in 1934. As Peter Wensberg retells the story, Clarence Kennedy and Land were discussing a name for the company's first product. Kennedy, with his classical education, offered "Epibolipol," which was somehow supposed to convey "sheet polarizer" in Greek. (*Epiboly* is also a biological term involving the rapid growth of cells into a thin sheet, which is a little like the way crystals formed in Land's invention.) That unpronounceable mess was vetoed. Kennedy then fell upon the suffix "-oid," perhaps because it suggested a characteristic set of properties, as in "spheroid." It also evoked the product's celluloid base. Besides, it sounded niftily futuristic and high-tech. Combine that with "polarizer," he told Land, and you have a name.

It wasn't perfect. Until it became a household word, readers often transposed the vowels, mispronouncing it as "poyla-rode." To this day people misspell it, swapping in an *o* for the *a*. But it stuck: Polaroid!

4 A transcript of the 1980 annual meeting includes this revealing exchange:
A shareholder asked Land about his goals when he'd been a young student. "Two things," Land replied crisply. "I wanted to become the world's greatest novelist. I wanted to become the world's greatest scientist."

From the end of 1943 into 1948, Project SX-70 produced hundreds of test instant photos. This set is dated May 13, 1946, and signed by Meroë Morse and Eudoxia Muller.

2 Development

By 1937, Land-Wheelwright was a healthy small concern with modest growth potential. Its innovations (and its innovator-in-chief) were still getting steady press, with a big profile soon to appear in *Fortune*. It wasn't making much money, but it was in the black. Headlight glare was a continuing, if dragged-out, discussion with Detroit; the American Optical sunglasses license was starting to bring in cash. Helena Rubinstein was offering the services of a polarized-light skin-analyzing gizmo called the Dermascope. Another product, a stumpy-looking anti-glare desk lamp, arrived on the market shortly after, and was eventually sent off to the prominent industrial designer Walter Dorwin Teague, who cleaned up its looks. Although neither version of the lamp sold all that well, it was the first of Land's many such design collaborations.

Nifty product ideas presented themselves in these years, like the polarized window. A porthole was made of two sheets of polarized glass, one pane able to rotate over the other, allowing the window to be gradually darkened, blocking the sun or the neighbors. A demonstration set of these windows was installed aboard a Union Pacific railroad lounge car, the "Copper King," in 1938. Passengers loved toying with the dark/light controls as they sped across the country, but the windows were expensive and never caught on with manufacturers. (Polaroid reintroduced them in the 1970s, calling them variable light transmission, or VLT, windows, and they sold slightly better this time around, making their way into about 2,000 airplanes.)

Then there was the idea that is still attempting to go mainstream: the 3-D movie. The system was simple, at least conceptually. We perceive depth because our eyes are placed slightly apart, and our brain is able to

reconcile the disparate angles they observe. Shoot two movies simultane-
ously, with lenses a few inches apart, project them them onto one screen,
and if you can figure out how to send one to the right eye and the other to
the left, your cortex will do what it usually does, and the image onscreen
will pop out.

Land's invention made that last step straightforward. Install two
perpendicular polarizing filters on a pair of eyeglasses and another pair,
in the reverse orientation, on two projector lenses; run two versions
of the film and one eye will be blocked from seeing each image. A more
sophisticated version of this system eventually allowed a single strip of
film to carry both images, on its front and back, so they stayed in sync. It
even worked in color.[1]

It was first demonstrated in 1936, but Polaroid 3-D made its public
debut at the 1939–40 New York World's Fair. For two summer seasons,
most big American corporations and many countries each put their best

1 For most people. Employees at Polaroid loved to tell the story about Harry Warner,
one of the Warner Brothers, who came by to see a demo and left completely unimpressed.
Land's team eventually discovered that he had a glass eye, which made his depth
perception zero, and viewing 3-D impossible.

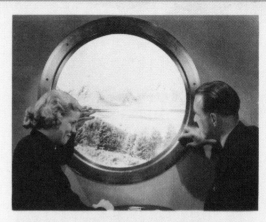

When the outside view is too bright . . .

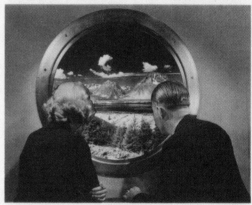

a turn of the control knob of the Polaroid Sight-Conditioning window brings brilliance down to the comfort level . . .

or if you tire of the view another turn cuts it off altogether. Twenty-nine windows like these are installed in the "Copper King" observation lounge car of the Union Pacific streamliner "City of Los Angeles".

OPPOSITE: Walter Dorwin Teague's redesign of the Polaroid Study Lamp. Handsome, though it didn't sell very well.

Aboard the Union Pacific railway's *City of Los Angeles*, travelers could lighten and darken the polarizing windows by spinning a knob.

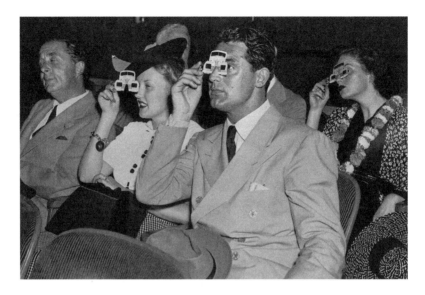

foot forward, displaying products and culture of every kind to millions of fairgoers. The event was part futureland theme park, part crass mega-advertisement, part earnest culture-building exercise. Technology's ability to solve problems was assumed, and the idea of going back to nature had no currency at all.

At the time, the upstart Chrysler Motors was known for innovative, high-tech carmaking, and its pavilion at the World's Fair was engineering-inclined too: A mural and film showed one of its Plymouth automobiles coming together, part by part. Visitors could buy special cardboard glasses with lenses made of Polaroid sheeting and watch wheel bearings and pistons zoom into place in three dimensions.

The Chrysler deal was Wheelwright's last hurrah at Polaroid. In 1937, his family connections had helped the little company find Wall Street financing. All good, but it meant Wheelwright's role was growing obsolete. Land was the chairman, president, and director of research, plus the source of virtually every idea, whereas Wheelwright was vice-president. Even his name had dropped off the door: That year, Land-Wheelwright Laboratories had been reincorporated, and was now called Polaroid Corporation. In 1940, Wheelwright left for a California vacation and essentially never returned. Land was now alone at the top,

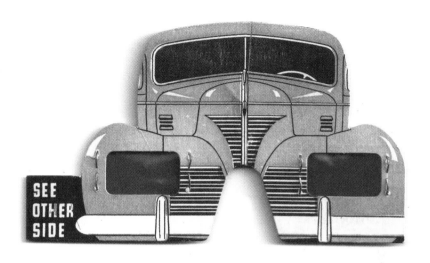

LOOK THROUGH THIS SIDE

To enjoy ten magic minutes in the Chrysler Motors theatre, use this Polaroid* viewer as you would a pair of eyeglasses. Look through it while the picture, "In Tune With Tomorrow" is on the screen. You will get the greatest thrill in movies and see the greatest thrill in motor cars.

Warning: This is not the type of viewer designed for sun glasses or night driving.

*Reg. U. S. Pat. Off.—Pat. Nos.
1,918,848 – 1,956,867
2,078,254 – 2,087,795
2,018,214 – 2,041,138*

Engineering research keeps Plymouth, Dodge, De Soto and Chrysler cars and Dodge trucks in tune with tomorrow. You get the good things first from Chrysler Motors.

As a souvenir! Take this home with you. Revolve the two windows over each other against bright light—rotate one. See glare go. Then put folded cellophane between lenses. See unusual color effects.

HOLD HERE

At the 1939–40 New York World's Fair, visitors to the Chrysler pavilion (one of whom was Cary Grant) could see the world's first demonstration of a 3-D movie through little Polaroid glasses that looked like new Plymouths.

with full control: He and Terre held a lot of stock, and he had formally been granted veto power over every corporate decision.

In these years, Land hired several people whose abilities would gradually become essential as his company regrouped. Howard Rogers, another Harvard chemistry dropout, had been working in a gas station when his brother mentioned this odd new company that might interest him. He had a scientific mind like Land's: far-ranging, given to creative flights. Mike Viola, a chemical engineer who worked with him in his later years, recalls a day when Rogers was able to take something he'd seen in a nature special on TV the night before—it involved glowworms, Australian caves, and the spacing of the worms' eggs on the cavern walls—and adapt it to a problem involving the distribution of light-sensitive crystals on a photographic negative. Land, the man everyone called a genius, routinely went out of his way to mention what a genius *he* thought Howie Rogers was.

If Rogers was given to those almost childlike bits of invention, Bill McCune, hired in 1939, was the designated grown-up. A tall, lean, MIT-trained engineer, he'd worked for General Motors briefly before arriving at Polaroid as a quality-control officer. McCune's job quickly became, as his colleague William Plummer puts it, "hanging onto Land's leg so he wouldn't float off into space." Like his boss, McCune was an aesthete as well as a technician, one who later in life cultivated a special affinity for customized Porsches. He stayed at Polaroid for fifty-two years, and ended up having more to do with the company's future than anyone except Land.

A discomfiting cloud lay over the 1940 season of the World's Fair. The previous year's Czechoslovak pavilion went dark, as Czechoslovakia had ceased to exist. The fair's slogan, "The World of Tomorrow," was changed to "For Peace and Freedom." It was obvious what was about to happen, and late in 1940, a year before Pearl Harbor, Land told his seventy-five employees that they were off to war.

There was a lot that Polaroid could do. The company produced millions of pairs of goggles for the Army, including a model that, like the windows of the "Copper King," could be variably darkened at the flick of a knob. Polaroid made optics for reconnaissance, bomb sights, and a system

of so-called "blind flying" filters that could darken a cockpit for a pilot but not his copilot, for training in nighttime maneuvers. It even began work on the first heat-seeking missile, code-named Project Dove.

Wartime production brought out one aspect of Land's personality that nearly everyone from Polaroid remembers: his ability to invent on the spur of the moment. Land once recalled to Al Bellows, one of his engineers, that an Air Force general had called to ask for advice about a problem with its gun sights. As Bellows tells it, "Land's reply was that he would fly down to Washington the next day to describe the solution. The general said, 'Oh, so you have a solution?' And Land responded, 'No, but I'll have one by then.' And he did—the ring sight based on circular polarizers, something he invented overnight on demand."

Even 3-D technology had a wartime application: Reconaissance planes could take photographs a few moments apart, after which they could be printed on a special film with polarizing dyes in the emulsion, then transferred to one sheet of acetate. Viewed with 3-D glasses, it showed the territory in dramatic relief, making it much easier for bombers to hit their targets. The print was called a Vectograph, and Polaroid hosted Vectograph-making classes in Cambridge. The course was called Polaroid War School. Soldiers learned a modestly complex procedure involving an ordinary darkroom and an extra couple of steps in which the film was run through a set of pressure rollers. More than five hundred men had graduated by early 1944.

One of Polaroid's projects even led to a medical advance. Polarizer crystals were made with quinine, which was also one of the few medicines available for treating malaria. It came from the bark of the tropical cinchona tree, which grew in only two places, one of which was the island of Java. Once Java fell to the Japanese in 1942, American soldiers—fighting both the Axis and the mosquitoes—lost access to this vital treatment. Two Polaroid chemists, Robert Woodward and William Doering, went at the problem, and in 1944, they managed to synthesize quinine for the first time. Although their process didn't actually lend itself to mass production, it was publicly trumpeted as a triumph. Woodward kept going, too, eventually synthesizing all kinds of organic molecules, from cortisone to cholesterol.[2]

2 Woodward later left Polaroid to become a Harvard professor, and in 1965, he won the Nobel Prize for chemistry.

All good, patriotic work. And problematic. Before the war, Polaroid had been a small company, and its only steady moneymaker had been the sunglasses business. In eight years, annual sales had grown from about $761,000 to more than $16 million. Polaroid had topped out at nearly 1,200 employees, and 87 percent of its income was coming from military contracts. Land absolutely hated the idea of firing people—he once said that during bad economic times, it was the duty of a corporation to provide work—and now he was going to have to take his company down to its prewar scale.

And here the tale really begins, with what Land later called "the apocryphal true story," the great and irresistible founding myth of Polaroid. In late 1943, Land joined his family on vacation in Santa Fe, and, on one mild day, went out for a walk with his 3-year-old daughter, Jennifer, carrying his Rolleiflex. He claimed later that he wasn't much of a photographer in those days, but he did take pictures of his little girl. At the fireplace afterward, she asked him a simple question: "Why can't I see the picture now?"

It's such a good story, so tidy, that you have to wonder if it happened precisely like that. We will probably never know. The Lands, then and now, are extremely private, and Jennifer Land DuBois has never spoken publicly about that day. The question she asked has been recounted in various phrasings, some more curious, some more plaintive. One early account even has Land asking the question on his own, with Jennifer merely a bystander. Whatever she said to him, Land's mental wheels started turning immediately.

He spent the next several hours pacing the resort (leaving Jennifer with her mother), roughing out a way to make it work. It wouldn't do to have a tank of chemicals sloshing around in a camera, but maybe they could be contained in little pouches, and then spread over the negative somehow? Then how would one print a positive? Lay the two together, pressing them between rollers, somewhat like the Vectograph machine did. How would you configure both negative film and positive paper in the back of the camera? What would happen to the unexposed silver on the film, which is usually washed out of the negative in a darkroom? Everything he'd learned in his previous work—about filters, about making

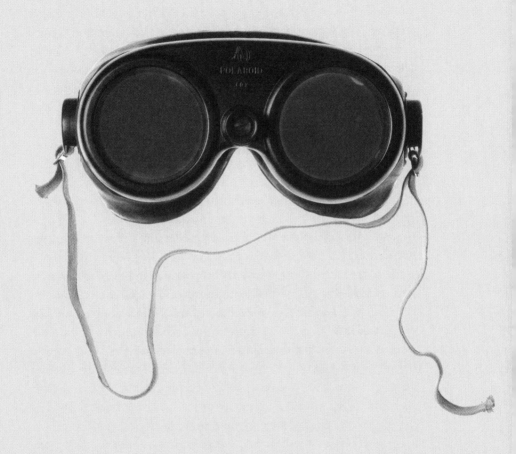

World War II pilots relied on
Polaroid for bomb sights, aerial-
photography lessons, and millions
of pairs of goggles.

tiny crystals and thin films, about optics, even about manufacturing and outsourcing—came into play.

Inventors sometimes experience a fevered paranoia just after they've had a great idea: It seems so clear and burns so bright that they are sure someone else will come up with the same thing any moment. Land's contemporary Chester Carlson, after his own invention of the Xerox photocopier, immediately called up a friend, dictated his scheme, and asked the friend to sign and date the notes. Land already had strong patenting instincts, and by coincidence, his patent lawyer, Donald Brown, happened to be on vacation in Santa Fe himself. The two spent half the night getting everything written down. Land, much later, joked that he roughed out the details in a few hours, "except for the ones that took from 1943 to 1972 to solve."

The last two wartime projects had been called SX-68 and SX-69 (the letters standing for Special Experiment). This one, SX-70, began in a little lab staffed by, as McCune later put it, "one girl assistant." That was Eudoxia "Doxie" Muller, who had been one of Clarence Kennedy's students at Smith. She delivered daily reports to Land each evening, and got new marching orders each morning at 6:30. The equipment she needed was built in Polaroid's model-making shops by Maxfield Parrish Jr., son of the well-known artist. An elfin and peculiar guy, known for his awful wardrobe and pretty girlfriends, Parrish had a reputation for being able to construct anything. In fact, modeling rather than sketching eventually became a bedrock of Polaroid engineering: If you had an idea for a design, you'd immediately call on the shop (or, in later years, one of the many shops) to mock it up and see if it would work.

Everything was recorded for the patent lawyers. Muller's daily reports were not only filed but also signed and witnessed. The record begins in December 1943 with a few pages of handwritten disclosure by Richard Kriebel, one of Polaroid's executives:

> On December 10, 1943, at his home, Edwin H. Land disclosed to me a novel self-developing film which when mounted in a camera of novel construction is adapted to produce a positive print shortly after exposure.

Within days, the circle broadened. On December 23, from a colleague named Frederick Binda:

> On December 13, Mr. E. H. Land called me to one side and said he had a secret to tell me. He said that for years he had been toying with the idea and dreaming about a new photographic camera in which you simply photograph a subject and from that same camera rolls out a finished picture. He told me that he now knew how to make such a camera.

The disclosures very quickly became specific and detailed. From December 17:

> The camera is provided with…means to pierce or break by compression the sacks of containers of developer. The film is then advanced through the camera through a sufficient travel to ensure development of the exposed frame.

Further disclosures over the next three years reveal the camera geometry, the composition of the film and paper, alternative ways of applying the developing chemicals, and hundreds of other details. Virtually every one begins with a note that the idea had originated with Land. His ability to invent on the spot had found a wide-open outlet.

That December, Doxie Muller became the first person in the world to see a Polaroid instant picture. It was bright yellow and not very attractive, but it was a recognizable photograph, and her little lab soon began to gain personnel, as Land gradually began moving resources from war work to SX-70. The reports got their own custom letterhead (POLAROID CORPORATION / CONFIDENTIAL / SX-70—DAILY DIARY). Improvements to the image sometimes brought instability. Some recipes made pictures that were not black-and-white but blue-and-white. Most often, everything was brown.

In 1944, Woodward was joined by another Clarence Kennedy protégée, Meroë Marston Morse. The daughter of a Princeton University math professor, she was a perfect Land hire: worldly, cool, charming, and focused. She played the harp, and her Cambridge apartment—its bay

Test photo of Land, March 13, 1944,
taken just a few months after Jennifer
asked her question.

window containing a lineup of enormous golden instruments—seems to
have made a major impression on every colleague who ever visited. John
McCann, who worked with her, says she was "always self-effacing and
supportive," and at the same time had the knack for exerting quiet power,
even in a roomful of male scientists. She was also reliably deferential to
Land, which probably made his life easier.[3] By 1946, the little team was
making decent, stable test pictures every week, and it couldn't happen fast
enough. During the war, Polaroid had peaked at 1,200 people; by then it
had shrunk to 240. "We didn't have any products to sell," McCune later
told an interviewer. "There was very little income and lots of outgo."

As it happened, the conditions for this technology to succeed were
excellent. Americans, unable to travel or spend during the war, their
gasoline and food and tires rationed, had been saving their money and
were ready to spend. As soon as civilian production resumed, instant
gratification took hold as never before. Regularly scheduled national
television broadcasts began in New York at the end of 1946, and four
networks (CBS, NBC, ABC, and DuMont) were on the air by 1948: instant
news and entertainment. At the University of Pennsylvania, an immense

3 Because Morse and Land worked so closely, there was a persistent rumor about an
affair between the two (and indeed, between Land and various of the Princesses over the
years). I don't buy it. Land surely adored Morse, and their bond went as deep as any in his
life, but too many people say that it never happened—people who were in a position to
know, like her sister Louise, who roomed with her in Cambridge.

electronic computer called ENIAC was switched on for the first time, computing artillery trajectories in seconds rather than hours: instant answers. Even the first microwave oven, built by Raytheon, appeared in commercial kitchens. Sure, it was the size of a phone booth, but it could cook a bowl of peas in mere moments. That same year, Chuck Yeager flew faster than sound for the first time.

To get a sense of the way big thinkers saw the world at the end of the war, consider a man named Vannevar Bush. Bush was a fairly well-known public intellectual during and after World War II. He ran the government's Office of Scientific Research and Development and helped to start the Manhattan Project. In July 1945, he published an incredibly prescient manifesto in *The Atlantic Monthly* titled "As We May Think." In eight brief sections, Bush describes a way of handling and processing information with a theoretical device called a "memex." It looks something like a desk, except with a big viewing screen on top. The memex contains a storage device so roomy that one could stuff in a thousand miniaturized documents per day and never fill it up. A user is able to call up any page he wants, and upon finding a passage that makes him think of another bit of information, he can call that up and link the two. On and on, document to document, and the memex is able to record that chain of thought in such a way that it can be named, saved, and consulted. The user navigates by means of levers and a keyboard, and can hold multiple images onscreen at once and exchange information with another memex.

This thing is, of course, a prototype Internet terminal. Vannevar Bush to a great extent figured out how to surf the Web in 1945. In fact, he went on to become a science adviser to President Truman, and later had a hand in the creation of the actual Internet. He lived until 1974, not quite into the digital era, but long enough to have sent a few e-mails.

Bush also talks about photography in "As We May Think," musing that "it would be advantageous to be able to snap the camera and to look at the picture immediately." He doesn't mention that his friend Edwin Land was, at that very moment, working on that idea, but he soon saw it in action himself. One experimental Polaroid photo, shot in 1947, is a sepia portrait of an amused-looking Vannevar Bush. The first Polaroid camera was pointed directly into the future.

Land, at the moment he
revealed his invention to the world,
February 21, 1947.

3 Seeing It Now

An ad executive once said that Polaroid was the easiest sell imaginable because "all you have to do is show the product." He was overstating the case, but he had a point. Edwin Land's great knack for demonstration, twinned with the party-trick nature of the instant camera, was always the best way to get people excited about Polaroid. In 1947, when he was ready to reveal it to the world, he handled its debut like a maestro.

It was at a bone-dry scientific meeting of the Optical Society of America, held at the Hotel Pennsylvania in New York City. Land and company had modified an 8-by-10-inch view camera, one of those large-format mahogany beauties, installing a back that could hold rolls of film and paper. A desktop processing rig with motorized rollers sat next to it. The Polaroid team had rehearsed over and over, knowing that in front of the press, they'd have only one chance to get everything right. On February 21, they arrived at the meeting just as New York was hit by a severe blizzard.[1]

The invisible ace that Land held in his pocket was an understanding of his audience. The seated members of the Society were certainly going to find his invention interesting—they were engineers and scientists. But the guys in the back of the room, newspaper and magazine photographers and reporters, had the real power, and they were another matter. Imagine what a 1940s newspaper photographer did every day. He went out, got his shots, and then hauled himself back to the office on deadline, whereupon the gnomes in the darkroom processed what he'd shot. If what he'd done was overexposed, underexposed, or otherwise lousy, he'd get a tongue-lashing from the photo desk. If only he could see it right away.

Land began speaking and setting up his demonstration, gradually taking his place in front of the view camera. He fired the shutter with a

1 For an extensive and vivid re-creation of this remarkable day, see Peter Wensberg's memoir, *Land's Polaroid* (1987). Wensberg had not joined Polaroid yet, but a few years later, after he did, he got to know nearly everyone who was employed there.

cable release, taking a picture of his own face. He had just exposed a big negative inside the camera, much as the guys in the press pool were doing with their beat-up Speed Graphics. A moment later, Otto Wolff, who was working with Land, pulled the negative out of the camera, in the process joining it face to face with a sheet of glossy photo paper.

Between the two sheets, at one end of the picture, lay one of the principal Polaroid inventions: the pod. Relative to its importance, it looked like nothing special: a slim foil packet, as wide as the photo, containing perhaps an ounce of thick chemical reagent; almost everyone at Polaroid called the contents "goo." Once the multilayer paper sandwich came out of the camera, it was run between two precisely made steel rollers, bursting the pod and spreading its contents smoothly between the film and paper. The goo stood in for a darkroom's baths of wet chemistry, and there was just enough of it that the print came out nearly dry. It had taken a lot of effort to get the pod right. It had to break open and spread its contents the same way every single time, which meant that it had to be precisely filled and sealed.

Wolff and Land switched on the motor driving the rollers, and fed the photo through, breaking the pod open and starting development. "Fifty seconds," Land told the room, and set a timer. As Peter Wensberg tells the story, Land was terrified that it would fail in front of the reporters, and in the photos of the event, he does seem a little less confident than was his usual mien. He had bet his company and the livelihood of his remaining employees on this moment.

As the timer counted down, the inside of that paper sandwich was undergoing some remarkably complicated processes. One side, the negative, dampened with goo, had developed in a few seconds. Where its silver-halide crystals had been exposed—in what were the lightest, whitest areas of the subject—they had turned dark. The remaining silver halide, unexposed, was being chemically induced to send its silver across to the photo paper, where it made the dark areas of the final print. That was one of Land's great breakthroughs: The stuff that normally went down a darkroom drain was instead being used to make the picture itself. The fifty seconds on the timer wound down, and Land grasped one corner of the print, steeled himself, and peeled it off.

What he revealed was a perfect sepia portrait of himself. It may have been an accident that the 8-by-10 camera produced a photo almost the same size as his actual face, but that only added to the eeriness: There was Land, sitting at a table in his striped tie, displaying a fresh picture in which he sat at the same table, wearing the same striped tie. Wensberg says that "a gasp rippled around the room," and the *New York Times* reporter immediately demanded that he do it again. Land happily complied. The Polaroid team spent the rest of the evening shooting pictures of the dinner guests at the conference, and answered all their questions.

The next morning, the shot of Land revealing his own mug got big play in the *New York Times*, along with an appreciative editorial. Newspapers all over the country ran the story. The following Monday, it was the "Picture of the Week" in *Life* magazine, then the alpha and omega of American photojournalism. Maybe not coincidentally, *Life* was another place run by harried photo editors who viscerally understood what he'd done, and they gave Land's doubled visage one of their very large pages.

Remember that amateur photography, in 1947, had come along only a modest amount since Eastman's first film in 1888. Yes, the cameras were better and more versatile, and color was becoming widely available. When it came time to process your pictures, however, you had two choices: build yourself a darkroom, or get your film to a lab. If you didn't live in a big city, you were probably mailing your film back to Kodak, same as in 1888. The leap to Polaroid was like replacing a messenger on horseback with your first telephone. "There is nothing like this in the history of photography" was how the unsigned *Times* editorial put it.

Land insisted that this was simply the way things ought to be. As he said many years later:

> Ask me a question. Okay, now suppose I say, if you will come back in seven days, I will give you the answer. Are you impatient?…Look, if the picture you get instantly is as beautiful as the picture you get by waiting seven days, then it is absolute madness to say that there is virtue in waiting.

Now came the less exciting work of turning an experimental model into a consumer product, and contracting for parts and manufacturing.

Among other problems, Land's team had trouble finding a camera shutter whose timing was accurate—nearly every one on the market was way off. Photographers had, unknowingly, been correcting over- or underexposed results in the darkroom. That wouldn't work if there was no darkroom.

Making film was the really hard part, though. It's one thing to take a few square feet of acetate and put micro-thin coatings of emulsions on them in a lab setting. It's quite another to spin them out at factory speeds, then slit them down to camera-size packets and seal them up for sale, conducting much of the process in pitch blackness.

Just as in its early polarizer days, Polaroid now called upon the giant of American photography, and signed a big contract. For the next twenty years, the negative layer in every frame of film assembled by Polaroid was made by Eastman Kodak. In these years, Kodak didn't consider Polaroid a competitor; instant photography was a curio, a fly on the elephant, and a fly that was paying rent to be there. Besides, if it got people in the habit of taking pictures, they'd eventually start shooting standard film as well. Kodak management said it explicitly, in a telegram to its salesmen: "Anything that is good for photography is good for Kodak."

Bringing up production took more than a year and a half, and the commercial debut was, once again, built around a powerful demonstration. On November 26, 1948, a sales team took fifty-six cameras plus a demonstrator and a batch of film to Jordan Marsh, the big Boston department store. It was the day after Thanksgiving, kicking off the holiday sales season, and Polaroid's people expected that the stock might sell out by Christmas.

The camera was called the Model 95, and its price had been $95, too, until a last-minute rethinking dropped it to $89.75. It was big, weighing four pounds, two ounces, and, implausibly, that had not been an accident. Cameras over the four-pound mark were considered professional equipment, and were more lightly taxed than smaller ones. After the prototype had come in at just over that weight, McCune had made sure it stayed there.

Notably, it was not called a Polaroid camera. That word, after all, was the trademark for a polarizing filter. The photographic gear was to bear the name of its inventor, and was labeled LAND CAMERA. Buyers sometimes

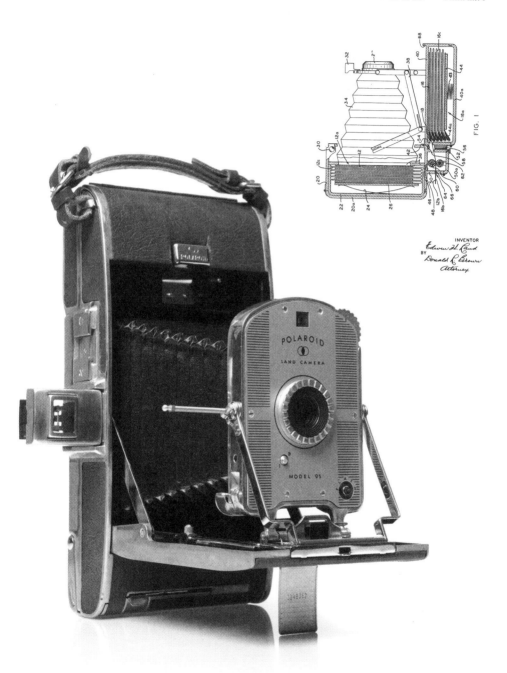

Feb. 10, 1948. E. H. LAND 2,435,720

APPARATUS FOR EXPOSING AND PROCESSING PHOTOGRAPHIC FILM

Filed Aug. 29, 1946 2 Sheets—Sheet 1

FIG. I

INVENTOR
Edwin H. Land
BY
Donald L. Brown
Attorney

The Model 95 went on sale in November 1948, and outsold even Land's optimistic projections.

TOP: The general patent for the Polaroid system. Dozens and dozens of specific processes and details were patented separately.

came away with the idea that the system couldn't be used anywhere near water. Most everyone quickly began to elide Land's name, and "Polaroid" soon ceased to mean anything except "instant picture," no matter what the trademark lawyers did.

At Jordan Marsh that Friday, the salesmen started taking pictures. This was not, mind you, the simpler Polaroid system that photographers came to know later on. This early film came in a skein of two interconnected spools that dropped into the back of the camera. After the photographer clicked the shutter, he or she threw a switch on the back of the camera, loosening the film, and then pulled out a long paper tab, tearing it off. Sixty seconds later, he or she unlatched a little door on the back of the camera, revealing a facedown photo surrounded by perforations, and peeled up the sepia print. It was not the greatest picture on earth, if you wanted to be critical about it, but it was *there*. It worked!

All fifty-six cameras sold out that day. So did the demonstrator model. So did all the film. The salesmen ended up standing on the countertops, because of the crush of the crowds. The same scene played out elsewhere. By the end of the year, the company had cash on hand totaling twice its liabilities. At the end of the first quarter of 1949, it was in the black again. The night before the product introduction, Land had suggested that Polaroid might be able to sell 50,000 cameras per year, far more than anyone else imagined possible. It turned out that even the visionary had lowballed himself. By the time the Model 95 was retired, in 1953, 900,000 units had been sold.

The criticism leveled at the Land system was that it wasn't real photography, that it was an amateur's gadget and nothing more. Its limitations were evident: small brownish prints, no permanent negatives. Deliberately or not, Land immediately took a big step to counter that idea, meeting an expert who in the coming years redefined what Polaroid photography could be. It happened during another Optical Society of America conference, and the man Land met was Ansel Adams.

Adams had, in the preceding twenty years, become one of the most powerful voices in photography as the medium had grown up. Along with Alfred Stieglitz, Edward Weston, and a few others, Adams had furiously advocated for photographs of documentary purity, and in the fine-arts

world, their little group had largely prevailed. He cut a larger-than-life public figure, too, with his soft felt hats and the mien of a brainy, irascible bohemian charmer.

He was a relentless technician and unsurprisingly, was taken with Land and his new invention. The men hit it off personally, too. As Adams said in an oral history he recorded for the University of California at Berkeley three decades later:

> Then we went to Cambridge and came over to this little laboratory, and he took my picture with a great big 8-by-10 camera....He sat me down under lights and things, and exposed the picture, processed it; there it was, brown and of rather awful quality. It was his very first experimental work. But by gosh, it was a one-minute picture! And that excited me no end; I mean the thought that you could really do that. So I told him that I was interested, that I felt that he had something absolutely unique, an historic step. So he said, "Well, I'd like you to be a consultant for the company and just send in your ideas."

That happened in November 1949. For a retainer of $100 a month, Land got Adams's formidable knowledge on tap, and a lot of reflected glory. Adams might have got away without doing much, but he threw himself into the consultancy. He was around the labs regularly, offering commentary and occasionally getting drunk with the chemists. He stayed on the payroll for the rest of his professional life, though as he hastened to point out in 1972, the stipend had risen to "considerably more than $100 a month, thank god." Whenever Polaroid introduced a new product line, Adams trooped off to the mountains or the desert to try it out. Back came reports packed with detail, containing rows of photos at varying exposures or apertures. Eventually he filed more than 3,000 of these memoranda. Adams tested each film's limits: its flexibility in varying light, its tonal qualities, its color and contrast range.

And the limits of that first film, called Type 40, were considerable. The warm sepia was not as awful as Adams said it was, but its tonal range was very limited. Anything red registered almost black, or rather brown, and

In 1949 the Saint—Leslie Charteris's spy-novel hero, later portrayed on television by Roger Moore—was already using the new technology to catch bad guys.

yellows came out dark, too. (In formal terms, it was orthochromatic rather than panchromatic.) At a time when color photography was beginning to become widespread, sepia images evoked not fresh new technology but Grandma's portrait in the attic.

Land knew this, and had from the beginning. His company's next big push, after resolving the production difficulties caused by the smash hit they had on their hands, was to turn brown-and-white into black-and-white. At this distance, it sounds like a modest goal, although he later told his colleague Mary McCann that it was the toughest single task Polaroid ever accomplished. Nearly everything had to be reformulated. Among the thorniest problems was that, in the most promising system, the particles of silver forming the print tended to pool, making dark areas of the photo strangely shiny.

Meroë Morse and her team kept the lab going nonstop in shifts. Morse herself turned in the fourteen-, sixteen-, eighteen-hour days that the project demanded, filing chipper daily memoranda to Land. In the summer of 1950, black-and-white film went out into the world under the name Type 41. It had rich blacks and good contrast. It looked really good, much better than Type 40.

And then, a few months later, it didn't.

One thing that sets Polaroid photography apart is that an instant print is unique. It is an edition of one, and thus it is vulnerable. If conventional prints get lost, you have the negatives. Polaroid pictures, on the other hand, had no safety net. And a few months into production of Type 41, a major flaw revealed itself. The prints were *fading*.

It turned out that a thin skim of the processing goo remained on the photo, so the print kept developing for weeks after it emerged, slowly turning white. The black-and-white prints were also terribly delicate. You could barely touch the surface without leaving a mark, and the emulsion was attacked not only by fingerprints but by oxygen. Consumers began to screech—*we lost the pictures of our baby's first birthday!*—and so did their camera dealers.

OPPOSITE: **On a day out in San Francisco, Dorothea Lange photographed friends with her Polaroid Land camera, and Ansel** Adams shot them all with his, producing this set of previously unpublished pictures. Photographs by Ansel Adams.

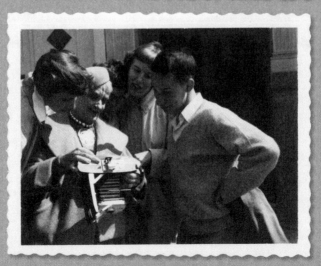

Morse's lab began to work toward a solution, and in a parallel project Elkan Blout, a Harvard chemist who'd been with Polaroid since the war, began trying to figure out a stopgap. In the end, the stopgap won. Starting in early 1951, every box of film contained a small test tube, capped with a plastic stopper. Inside was a wide felt swab soaked in a viscous liquid. Once you'd made your photo, you'd pull out the little squeegee, cover the surface of the photo with the liquid, and then let it dry, away from dust or sand. The stuff gave off a vinegary stink and seemed faintly poisonous.

Print coater was a pain to use. Land's elegant one-step photography had just become two-step photography, with a second step that smelled funny and left you wanting to wash your hands. It turned out, though, that the public was willing to accept this fly in the ointment, and it may have saved Polaroid. The product returns subsided; sales went back on their skyward trajectory. Every black-and-white Polaroid print required a coater until 1970, and a few professional lines still called for it into the 2000s. A whole generation came to associate Polaroid photography with that sharp smell.

And with photos that don't last, which was a bad rap. Polaroid pictures (coated or not) are no less stable than conventional ones. Both fade if left in bright sun, and hold up well if they're not. Somehow, though, people still think that Polaroid pictures inevitably degrade. It may be that the instant nature of the film makes it seem ephemeral or fragile. A 1980 song by the British singer-songwriter Billy Bragg contains the lines, "The Polaroids that hold us together / Will surely fade away." They don't have to, though. Many of the first tests, from 1944, look just fine.

The long-term effect of the print-fading scare, though, wasn't the smell of the coater or the bad rap on durability. When you coated a Polaroid print, it stayed wet for perhaps fifteen minutes. Your natural reaction was to hold the print by its edge and flap it around until it dried off.

A lifetime later, people still wave their instant photographs as they develop. The later forms of Polaroid pictures are always dry to the touch, because the image is permanently sealed under a sheet of clear Mylar. Flapping those pictures back and forth has always been pointless. Yet nearly everyone does it. When Outkast turned the practice into a refrain ("Shake it like a Polaroid picture"), Polaroid felt the need to put out

a stuffy press release. "Shaking or waving can actually damage the image," it said. "Rapid movement during development can cause portions of the film to separate prematurely." Didn't make any difference. Everyone kept shaking.

Ask a twenty-first-century picture-taker why he or she is waving that photo around, and you'll hear something vague about "making the picture develop faster." It's often followed by a quizzical pause in which you can see doubt cross the speaker's face: *You know, actually, I have no idea why I'm doing that.* Certainly few people know that it's a long-dead emergency solution to a long-dead problem, a ghost in the machine.

If you are the sort to see beauty in technology, to immediately ask how things work the way they do, instant photography is an extraordinary humanistic-scientific achievement. But if you're not—and Polaroid's photochemistry is just too complicated for most people to fathom—it seems to exist in the realm not of science but of magic. It has the same qualities as a stage illusion: There are special words to make things happen—*abracadabra! Say cheese!*—followed by a snap, a flash of light, and revelation of the results. Shaking your Polaroid does not just give you something to do while it develops. Rationally or not, you're waving a magic wand.

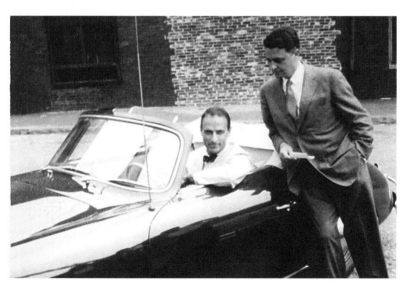

Edwin Land (with Polaroid print in hand) and William McCune (with Porsche), outside the Osborn Street labs in 1958.

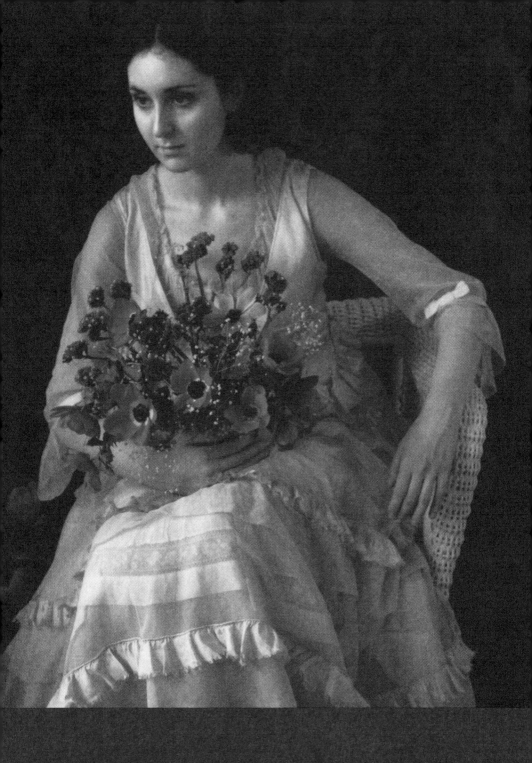

Marie Cosindas was perhaps the first artist to draw out the potential of Polaroid color, in her painterly portraits (such as this one from 1966, titled *Vivian Kurtz, Boston*) and still-lifes.

4 Meet the Swinger (and everything else)

What was it like to work at Polaroid in its heyday?

Talk to the old employees, especially the scientists, and you'll hear that it was the greatest place ever to have a career. For one thing, the company had a lot of money to spend. Because the Land photography system was a technological outlier, with all the necessary patents locked up, it was going to be a long time before it was commercially challenged. Polaroid was able to sit out the price competition that can force companies to nickel-and-dime their customers, suppliers, and employees. The profit margin on a package of film was something like 60 percent.

That meant there was lots of room in the budget to make things interesting. If Land wanted to set up a lab to study the way in which the eye and brain perceive color (as he later did), he could afford to. In a speech he gave in 1965, Land pointed out that in the late 1940s he'd asked Howard Rogers to start thinking about how to produce color instant pictures. For two solid years, Rogers just watched and considered. Then he came to Land one day, saying, "I'm ready to start now." As Land explained with pride, "My point is that we created an environment where a man was expected to sit and think for two years." Not was allowed to—was *expected* to.

One department was formally called "Miscellaneous Research," with a budget that was anything but an afterthought. The longtime Polaroid researchers John and Mary McCann spent most of their careers in Miscellaneous Research, and eventually married. In fact, a lot of Polaroid families formed—not least because at the time, Polaroid hired more women than most companies, and was relatively good about things like maternity leave. The culture of logging long hours also tended to focus Polaroid people on each other.

Much of Land's research, miscellaneous or otherwise, took place in a few old buildings around the intersection of Osborn and Main streets in Cambridge. Although Polaroid later occupied a big corporate campus at nearby Technology Square, the shabby Osborn Street labs (which Land once called "a few wretched buildings") were where he spent most of his time. They had once been Alexander Graham Bell's offices, the place where, in 1876, the first long-distance telephone call had been received.

These were America's headiest years of corporate research and development. Things like color television (from RCA and CBS) and silicon chips (via Bell Labs, Fairchild Semiconductor, and Texas Instruments) were popping into American lives at an astounding clip. Land himself expounded on this in an essay called "Basic Research in the Small Company," in which he laid out his dream of a thousand small corporations, each grossing $20 million, each spending 5 percent of that amount on research every year. That would contribute $20 billion to the national income, employ two million people, and:

> [Y]ear by year, our national scene would change in the way, I think, all Americans dream of. Each individual will be a member of a group small enough so that he feels a full participant in the purpose and activity of the group. His voice will be heard and his individuality recognized.

That's Silicon Valley, right there.

In fact, that idea of making people whole through rewarding work lives—one that many of today's tech entrepreneurs have taken to a cartoonish level, stocking their offices with foosball tables and snacks—recurs throughout Land's career. He had a romantic notion that everyone at Polaroid, from the Nobel candidates down to the people stuffing film into boxes, should feel like part of a seamless movement. Finding the inner innovative strength within people, he said, was one of his great goals. He once said that he saw his employees as tulip bulbs in the cellar: Bring them out into the world, give them water and light, and an amazing number of them will come into flower. At the corporate Christmas party in 1958, he told his staff:

We want to…make the working life of every single American a challenging and rewarding life. Now, I don't mean that you'll be "happy," I mean you are going to be unhappy—and very productive—in exciting and important ways. You'll be unhappy part of the day. You'll fix that by doing something worthwhile, and then you'll be happy for four hours; the next morning you'll come in unhappy, and you'll fix that by doing something worthwhile that adds on to what you did yesterday. So the accumulative product… is a building of some-thing.…You would never dream of giving up the splendid years of misery involved in raising a child. Well, a job should be like a child.…We are going to make American industry into this rewarding kind of life. I am telling every one of you that I want in Polaroid and will have in Polaroid only those people who are out to build an America like this.

To which most cubicle-dwellers today can say only, *Wow.*

He caught flak from hardheaded financial types for this kind of talk. As early as 1949, the financial press was saying Polaroid stock was overvalued. A publication called *Financial World* noted "excellent growth potentialities," but added that the share price could not be "justified on an earnings basis." Those who ignored the advice of those editorialists and bought it anyway became very rich. In 1948, the year when the Land camera appeared in late November, Polaroid took in $1.48 million. A decade later, it had grown to $89 million in sales; ten years after that, in 1969, it was nearing half a billion. Even as the press kept saying "the stock is overvalued," it kept going up. After rising almost nonstop through the fifties, it split 4-for-1 in 1964, and split again in 1968. It became a glamour purchase, and even against the advice of some of their brokers, people kept buying shares.

That growth spurred not just research but product development. A smaller camera came first, in 1954. Called the Highlander, it was successfully marketed to women, because Polaroid's salesmen had figured out that moms (who took a lot of family photographs) had found the large earlier models difficult to wield. Transparency film for shooting instant slides, industrial items like infrared film, and an excellent professional camera

called the Model 110 all took off, to varying degrees, during the 1950s. But
one new product exemplified what Polaroid was all about. It was a new
black-and-white film, created in Meroë Morse's lab and introduced in 1959
under the innocuous name of Type 47.

A bit of background here: Every variety of photo film carries a number
indicating its light sensitivity (its "speed"), known as its American
Standards Association (ASA) number.[1] Low-speed, or "slow," film
requires bright sun or studio lights. "Fast" film can be used in dimmer light,
but it typically makes grainier pictures. In 1959, most slow film was rated
ASA 100 or less. The fastest stuff you could usually buy, Polaroid or other-
wise, was ASA 400, just barely sensitive enough for a sunny indoor setting.

Type 47 was rated ASA 3000. The grain was unobtrusive, the range
of grays was superb, and the blacks were deep and lustrous. You could take
pictures—real ones—at a nighttime party without using a flash. In the
dimmest of rooms, you could use an accessory called a "Wink-Light" that
filled in the shadows. Type 47 was the closest thing thus far to Land's ideal:
erasing the impediments that came between photographer and subject.
The engineer Al Bellows, who began working at Polaroid a few years after
Type 47 appeared, once asked Morse how on earth she'd pulled it off. She
explained that, among other things, the emulsion was kept extremely thin,
to better react to the small amount of light that struck it, and its backing
was made reflective, so light bounced back through the emulsion and
exposed it twice.

The next great innovation was going on next door to Morse's lab on
Osborn Street. Rogers's two years of sitting and watching had been only
the beginning of Polaroid color. Thirteen years of synthesis and analysis
followed. From the 1957 corporate annual report: "Our research in the field
of color has advanced ... to the point where full-color prints are being made
directly in Polaroid Land cameras." That year, according to McElheny's
biography, Land carried one of those prints, showing a young woman in a
brilliant red silk coat, on a visit up to Rochester. He showed it to Eastman
Kodak's research chief, a man named Henry Yutzy, who immediately said:
"That's commercial." In other words, good enough to start setting up
a production line—one on which, once again, Kodak supplied negatives
and expertise.

1 Today, the benchmarks are maintained by the International Organization for
Standardization, and the measurement is called not ASA but ISO.

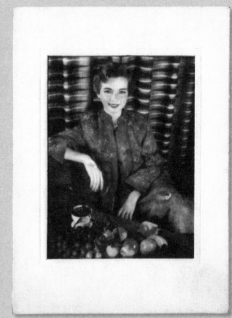

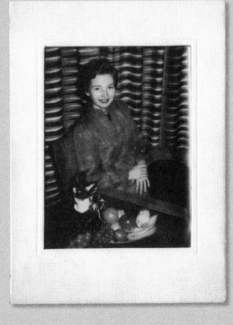

Polacolor tests from late 1956 and early 1957. A photo from this series was the one Land showed to Kodak's research chief, getting the quick and gratifying response: "That's commercial."

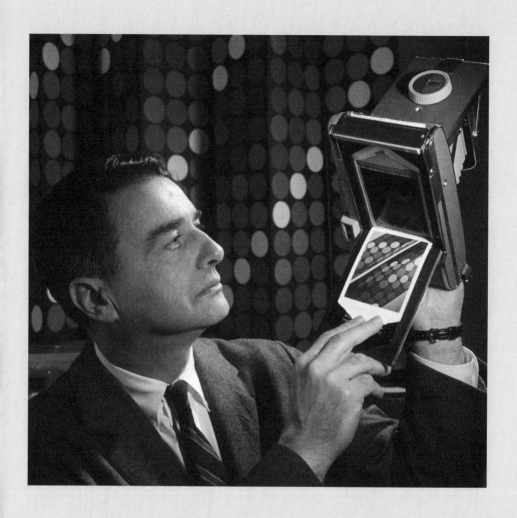

Land poses for *Life* photographer
Fritz Goro, marking the introduction
of Polaroid color film, 1963.

Polacolor film finally arrived in stores in 1963, with fanfare and press, in both the old roll format and a new cartridge. The matching new camera, called the Automatic 100, still required the photographer to pull a tab (two tabs, actually) and peel the picture off its negative, but the system was much improved. The photo now developed outside the camera, so you could shoot your next one while its predecessor steeped. This camera was also lighter and easier to handle, and had an electric-eye exposure sensor— a precursor to today's point-and-shoot models.

The Automatic 100, its descendants, and Polacolor film stayed at the center of Polaroid's line for a decade, and "pack film," as this format came to be called colloquially, was arguably the most profitable product Polaroid ever made. Even after it was technologically outflanked in the 1970s, it remained the cheapest way to take an instant photo, and a lot of enthusiasts insist that it still produces the best instant pictures.

It was a big strange molecule, invented by Howard Rogers, that lay at the heart of Polacolor. Rogers had figured out a way to couple the dyes (which had to migrate across to the positive) to the developer (which processed the negative itself). Three layers of the film were sensitive to blue, green, and red light. Exposed areas of those negatives became dark. The opposite-colored dye-developer molecule lay beneath each of those layers, and when the chemistry was activated after the pod was burst, those big molecules began to migrate toward the photo paper. The exposed dark areas took up the developer, blocking the dyes and preventing them from reaching the image; unexposed lighter areas let the dyes through. If you were to slice open a piece of Polacolor film and stick it under an electron microscope edgewise, you would see speckles of three colors, laid down in perfect layers where they'd landed.

Just before its introduction, a last-minute dive into the lab (mostly by Land himself) had reformulated the color film so it didn't need a coater. Yet once again, it was an imperfect product. Buyers soon found that, as their color prints dried, some of the image layers shrank a bit, causing the photos to curl up tightly. A solution was soon packed into every box of film: a set of print mounts, little cardboard sheets with adhesive on top. Glued down to the stiff backing, a fresh print stayed flat. Once again, life at the technological cutting edge came with an irritating dose of reality.

TOP LEFT: **Land and Cosindas swap places, 1969, in a Polaroid snapshot by Meroë Morse.**

TOP RIGHT: **Land at home in Cambridge in 1972, in a portrait by Marie Cosindas, with (as usual) Polaroid photos arrayed before him.**

ABOVE: **Land in his Osborn Street office, with top hat and many telephones, 1958.**

Amateur photographers embraced Polacolor, but the pros remained reticent. As late as the 1970s, many felt that black-and-white was documentary and honest, and that color was for Hollywood fakery. Even the openminded Ansel Adams, who enjoyed playing around with everything Polaroid made, stuck to black-and-white for his serious work. But he did encourage at least one of his students to start working in color.

That was Marie Cosindas. A Bostonian who had taken Adams's workshop in the late 1950s, she'd been recruited by Stan Calderwood, Polaroid's top marketing executive, who liked her photographs and offered her black-and-white film to shoot. In 1962, he called her up and said, "Come over—we have a product that may interest you." It was preproduction color film, and she took to it immediately. "The emulsion had, if I remember, eight layers," she recalls today. "You could almost look down into it. I fell in love. You know, I'd originally wanted to be a painter, but I couldn't stand the isolation in the studio. This film liberated me."

Cosindas shot a lot of portraits—Land once described them as having "overpowering clarity in suddenly seeing through a new face to the person within"—as well as unique series of still lifes. The latter works, especially, are composed like oil paintings, with luxuriant textures of fruit, fabric, flowers. They are extremely unusual, even outré, for this era—not severe and hard but lush, intense, organic, almost visibly juicy, in a way that prefigures the highly saturated compositions that are in favor today. Cosindas got more punch out of those little Polacolor frames than nearly anyone, and in her larger-format work especially, the subjects just about leap off the wall. For her show at the Museum of Modern Art in 1966, she had to persuade MoMA curator John Szarkowski not to frame her photographs with the customary white mats. "Because the Polaroids are so small," she explained, "when you put them on a white board, they become diminutive. If they have a tonality around them, they open up, like Persian miniatures." She got her colors, though she wasn't able to persuade Szarkowski to repaint the gallery to match.

Color, black-and-white, automatic cameras, and even fields that didn't pan out, like photocopier technology: They were all created by independent teams at Polaroid, working on their own, barely cognizant of one another, occasionally crossing swords. (One Land protégé,

Stephen Benton, invented the rainbow hologram that now appears on almost every credit card.) Some projects were almost like graduate-school dissertations. When Holly French (now Sarah Hollis Perry) was hired in 1957, Morse sent her a memo saying that her chief assignment was "the study of how to make our kind of photography an indigenous American art." She was expected to do so by engaging the residents of an entire small town to take pictures and see what they came up with. This is not the sort of project that corporations typically hand to 22-year-olds, but Perry says it was not all that unusual at Polaroid. "You know, they used to invent jobs for people," she explains. (She does admit that the small-town project never went anywhere.)

These little teams did not operate entirely without interference, because Land was at the top of every invisible organizational chart. An anonymous former colleague once described his involvement to *Business Week* thus: "Don't kid yourself, Polaroid is a one-man company." Land circulated among the offices, roving, probing, asking questions, now caught up in one project, now sucked into another, pausing only to catnap in a Barcalounger he kept in his cluttered office. Occasionally, beleaguered employees hoped he would get obsessed with something far away from their purview, so they could avoid those late-night phone calls. Nan Rudolph, who came to Polaroid in 1958, recalls that Land sometimes popped into her lab and asked to sit in the darkroom, just to hide out from questions and think. (She'd make him mushroom soup on a lab burner.) He wasn't kidding, some years later, when he said, "My whole life has been spent trying to teach people that intense concentration for hour after hour can bring out in people resources they didn't know they had."

Science, of course, does not sell itself, and in these years, the rest of Polaroid more than held up its end. The people marketing and promoting instant photography were marshaled not just by Land, who pretended that he didn't much care about that part of the business, but also by Stan Calderwood. A high-energy, larger-than-life man who favored bow ties, Calderwood was known for his boisterous manner and fine tastes. He grasped that Polaroid could be positioned as an aspirational product, and should be packaged and marketed that way. With some prodding from Jack Dreyfus, the Dreyfus Fund founder and

a major shareholder, Calderwood and Land hired the ad agency Doyle Dane Bernbach in 1954.

These years were the very beginning of the golden age of American advertising, the era now called "the creative revolution," when illustrations surrounded by expository prose gave way to clean, witty graphic design. DDB, run by cofounder Bill Bernbach, was the hot shop, and getting hotter: Its campaign for Levy's rye bread—"You don't have to be Jewish to love Levy's," accompanied by photos of multiethnic models, chowing down on pastrami sandwiches—was soon to become the talk of the ad world. Within a few years, DDB began work on its groundbreaking ads for Volkswagen, transforming that weird little German car from from ugly to adorable, and from Nazi invention to hippie icon.

Before Bernbach stepped in, Polaroid's ads had been made by the large agency BBDO, and showed cameras buried in an ocean of print, surrounded by arrows, bubbles, and a riot of conflicting typefaces. Bernbach swept out the clutter, first with his pioneering art director Helmut Krone, then delegating the job to the team of Phyllis Robinson (who wrote the copy) and Bob Gage (who designed the ads).

Gage and Robinson made Polaroid virtually their entire professional life. Robinson was a rarity—a woman in a testosterone-soaked business—but she more than held her own, raising a daughter along the way, eventually moving to Rome (but, at the client's insistence, continuing to work on Polaroid). She and Gage drove home simple messages: Polaroid pictures could be beautiful, because the materials were so good. (The team called this the "quality campaign.") Instant photos could draw people together, because they were shared immediately. And they were fun, because you saw them right away. "If you're not taking color pictures with the new Polaroid Colorpack camera, there's something left out of your life," went one heart-tugging TV ad, showing a dad and his daughter out for the day in Central Park, surrounded by carriages, balloons, and calliope music. Even better was a print advertisement that bore just one sentence. It showed a charming photo being peeled off its backing, and read: "It's like opening a present." Exactly.

The enthusiasm that Bernbach's team brought to Polaroid was mirrored by Calderwood's people, especially two fellows named

SALVADORE DALÍ: This enlargement was made from an actual 60-second Polaroid Land picture. Notice the exceptional quality in detail and tone—characteristic of pictures taken with Polaroid's new panchromatic films. Inci-

dentally, the newest of these films has the amazing speed of 3000. It lets you take superb 60-second pictures indoors without flashbulbs. Polaroid Land Cameras are priced from $76.85. See your dealer for a demonstration.

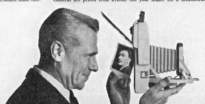

TOP: **Salvador Dalí for Polaroid, in a portrait by Bert Stern, 1958.**

LEFT: **Stern's portrait of Jessica Tandy and Hume Cronyn, circa 1958. The original print, shot with a standard Polaroid camera, is damaged but still vibrant.**

Paul Giambarba and William Field. Giambarba was a freelance graphic artist, one who never worked for Polaroid formally. But starting in 1957, and later working for the in-house design department established by Field, Giambarba began establishing a unique look for Polaroid's packaging and graphics. Until then, the company's logo had been set in a typeface in which the *o* and the *a* looked almost identical, a bad idea when your company's name is often misspelled "Poloroid." Its packaging was pale gray with red accents (coincidentally or not, MIT's school colors), studded with little representations of overlapping polarizers. "Soap bubbles," Giambarba called them, and it's true—they washed out and floated away. If you walked into a photo store, you saw two things: the yellow blare of Kodak, and then ... everything else.

The new logotype used a handsome typeface called News Gothic ("the only decent sans serif face that was available to us," Giambarba recalls today). The boxes got black end panels and white bodies, and each product was differentiated by a bright accent color. The result conveyed cool, modernist intelligence, and those black-end boxes, stacked up behind the counter, popped out against the sea of Kodak yellow.

These were the early days of brand identity, and Field, working with Giambarba, continued to refine Polaroid's for the next twenty years. The signature design innovation came in 1968, when they wrapped Polacolor film in bright, bold rainbow-striped packaging, with barely any text on the box. Those bright bars of color soon came to dominate all of Polaroid's graphics, and many others. (In fact, they became so ubiquitous in the next decade, appearing everywhere from Apple Computer's logo to RCA's color-TV ads to the gay-pride flag, that Polaroid reduced their prominence in order to maintain a distinctive look. A little rainbow nugget remains in the company's logo today.) A few times in the early 1970s, Polaroid convened a graphic-design summit, bringing in the best minds in graphic design to look over the previous year's work. The legendary Paul Rand—the man who drew the IBM, ABC, and UPS logos, and about a hundred others everyone knows—sized up the work coming out of William Field's department and delivered a concise verdict: "You don't need me. You don't need *anybody*."

ABOVE and OPPOSITE, TOP: **Field's**
design department took on
projects large (trade-show
booths) and small (packaging for
the budget-priced Zip camera).

OPPOSITE, BELOW: **Giambarba's logo**
and package redesigns, before
and after.

The image Calderwood cultivated was bolstered by a wave of fine-arts interest. Aided by Ansel Adams's proselytizing, Polaroid soon began to catch the eye of lots of prominent photographers. Some, like Philippe Halsman, used instant film mostly for lighting tests before shooting conventional negatives, but others embraced it on its own merits. Bert Stern, who later gained serious fame for conducting Marilyn Monroe's final shoot, produced a series of celebrity portraits that became magazine advertisements for Polaroid film. Salvador Dalí glowered through his mustache; Louis Armstrong grinned over his trumpet; Jessica Tandy and Hume Cronyn posed together, their faces overlapping artfully. In the ads, DDB's art directors bled the photos right to the edge of the page, with tiny (and logo-free) text in the bottom margin.

At least one Polaroid artist wasn't even a photographer at all. Starting around 1967, William Anastasi started making strange and excellent conceptual artworks in which he pointed a camera at a mirror, reproducing himself as he reproduced himself. In *Nine Polaroid Photographs of a Mirror* (1967), he took that wheels-within-wheels conceit for a dizzying spin, because the mirror itself was part of the final installation, obscured in stages by the photographs. As his face disappears from the looking glass, it recurs in the photos—but it's also blocked by the camera, and it multiplies as the later images incorporate the earlier ones. It's like an M. C. Escher print pulled from real life, and it would have been almost impossible to make without Polaroid film.

Not only did artists begin discovering Polaroid; Polaroid began coming to them. Meroë Morse, with her art-history background and her aesthete boss, had the idea that Polaroid could support the artists who showed off the product at its best. Starting in the 1950s, she (along with other executives, including Calderwood) began to make informal deals with photographers like Paul Caponigro and Minor White. Polaroid would keep the artists supplied with film in exchange for some of their best pictures and technical advice. The company soon accumulated a small collection, and little exhibitions began to appear around the offices and labs.

A lot of the photographs were by Ansel Adams. His connection to Polaroid had deepened as he and Land grew close, and at one point in the

In 1967, the conceptual artist William Anastasi photographed himself photographing himself, facing a mirror that gradually disappeared under those very photographs, for *Nine Polaroid Photographs of a Mirror*.

Ansel Adams's *El Capitan, Sunrise, Winter, Yosemite National Park, California, 1968*, was one of his favorite photographs, and is an astounding example of what large-format Polaroid film could do. Photograph by Ansel Adams.

mid-1950s, he began pushing Land for a truly professional-grade Polaroid film, something that could be used in the back of the large-format wooden field cameras he favored. Land expressed skepticism: How many people would buy it? "Oh, gosh, I can think of fifty right now," Adams told him, exaggerating a bit. Soon enough, Land made it happen. Single-shot packets of 4-by-5-inch Land film came first, and then, in 1961, Adams really got his wish: a film called Type 55 that produced a negative as well as a print.

It wasn't a huge profit maker, but its impact was enormous. Suddenly, the fundamental limit of Land photography, its irreproducibility, was no longer an obstacle. You could do everything on Polaroid film (in black-and-white, at least) that you could do on conventional film. A number of the great Ansel Adams landscapes, especially *El Capitan, Sunrise, Winter, Yosemite National Park, California, 1968*—one of his own favorites—were shot on Type 55. Although the negative required a quick wash in a chemical bath after processing to clear and stabilize the image, that could happen under normal light, later on. Type 55 (and its smaller-format siblings, Type 105 and Type 665) meant that anyone could, for the first time, take serious photographs without waiting for them to be processed.

Which brings us to the subject of sex.

We will never know exactly who first figured out that using a Polaroid camera meant whatever happened in front of the lens never needed to be seen by a lab technician. It is clear, though, that it happened early on. There are plenty of naughty first-generation Polaroid photos out there to confirm that instant photography's success was at least in part built on adult fun. At the time, "camera club" sessions were a popular fad: afternoons with a hired nude model, allowing amateur shutterbugs a few hours to indulge their artsy-prurient sides. Bettie Page, the 1950s pinup, got her start in these places, and pornography historian Joseph Slade has noted even frontal nudity in her Polaroid photos from these sessions. The Kinsey Institute has many such Polaroid pictures on file, too. By the 1960s, ads were appearing in certain magazines for a woman who would pose for nude Polaroid snapshots for a price.[2]

Did Polaroid itself know? Of course. Donald Dery, Polaroid's long-time director of corporate communications, puts it this way: "We didn't acknowledge it, but we always talked about 'intimacy.'" Sam Yanes, who

2 Thanks to Jim Linderman, proprietor of the blog Vintage Sleaze, for uncovering this last bit of vintagey, sleazy info.

succeeded him in the job, offers a little more detail: "There was a subject-photographer relationship that didn't exist with a regular camera...an intimacy, and we felt it was one of our main features. I never saw any research that said X percent of sales went for bedroom pictures, though."

The attraction lingered long past that relatively repressive early era. Woody Allen's scandalous relationship with his not-quite stepdaughter, Soon-Yi Previn, was revealed to the world in 1992 when her mother, Mia Farrow, spotted a stack of nudie Polaroid photos on his mantelpiece. In Russia, between the end of Soviet repression and the arrival of the Internet, Polaroid pornography was huge. It's not clear exactly how much film was destined for X-rated work, but for a couple of those years, Russia accounted for 10 percent of Polaroid's worldwide film sales.

The privacy of Polaroid photography also opened up what artists could do. Consider the work of Robert Mapplethorpe, who as a young artist in the late 1960s worked mostly in collage. He first acquired a Polaroid pack film camera with the idea of integrating its pictures into those collages, but he quickly began to appreciate the photos themselves. Although he was deeply involved with (and constantly photographing) his partner Patti Smith, his photos were often homoerotic, and grew more so over the years, as he figured out his sexual identity and embraced it, both in life and with a camera. If he'd sent some of those pictures of leathermen and naked boys out to a lab, even one that was accustomed to printing artists' nudes, he'd probably have been arrested. Working with a Polaroid camera as he did, everything stayed in his studio until he was ready to show it—and until, in the mid-1970s, the world (or at least part of it) was willing to see this work as art rather than smut. Though Mapplethorpe eventually switched to shooting mostly conventional film, his Polaroid work is extensive enough, and compelling enough, to have had its own retrospective at the Whitney Museum of American Art in 2008.

Of course, Polaroid was not above dropping a coded hint, now and then, and in 1965 it rolled out a product whose name telegraphed libidinous fun. Color film, introduced two years earlier, had been a hit, so much so that the black-and-white factories were idling. The solution was a genuinely inexpensive camera, one that took only black-and-white pictures. The buzzword of the era was "youthquake"; baby-boom

OPPOSITE: **When using Polaroid film to photograph himself (as here) or others, Mapplethorpe could make sexualized photos without interference.**

The Swinger, introduced in
1965 and aimed at teenagers,
sold like crazy, even though its
photos were small and black-
and-white-only.

teenagers were becoming a real consumer group, with different tastes from those of their parents, and the new camera was pointed squarely at them. The design (by Henry Dreyfuss) was groovy: mod white plastic with a silver-and-black bezel. It was lightweight, meant to dangle from the wrist on a lanyard, and Polaroid got the retail price down below twenty bucks. It was nearly idiotproof: The camera's viewfinder lit up with the word YES when it saw enough light to take a photo.

Phyllis Robinson came up with the name. As she recalled in an interview at the Paley Center for Media in 2006, Land had picked up the camera during a meeting in Cambridge, and "this very dignified man slipped the strap onto his wrist, and walked up and down his office swinging it. And I thought, oh my god: the Swinger." It was perfect for the moment, suggesting youth, movement, dancing, play, lightheartedness. For kids in the midst of the sexual revolution, "swinging" meant something that went entirely over their parents' heads. "The most spontaneous camera in the world," read the instruction manual. You bet.

Robinson wrote a jingle, "Meet the Swinger," set to a nifty surf-rock tune by the composer Mitch Leigh (who in between ads was also cowriting *Man of La Mancha*). DDB shot a commercial in black-and-white (like the pictures the Swinger made) of frolicking teenagers on a beach, one of whom turned out to be the not-yet-famous Ali MacGraw. Robinson had spotted her in New York, and had insisted on casting her even though she was ten years older than the team had planned. "Trust me," Robinson had insisted, and the moment the future *Love Story* star stepped into the room, they knew what they had. "It's more than a camera, it's almost alive / It's only nineteen dollars and ninety-five," the lyrics went.

Never mind that the pictures the Swinger made were only okay: It was another smash, at least for awhile. Polaroid sold more than seven million Swingers, and lots of black-and-white film. Teenagers being a fickle market, the product line lost steam after only a few years, but it had done what it was supposed to do: get those baby-boom kids hooked.

The Swinger's photos were tiny, barely 2 by 3 inches, making it unsuitable for much more than snapshots. That was not a problem for another project that came out of Polaroid a few years later. Like so many things, it began with a capricious yet firm demand from Land. For the 1976

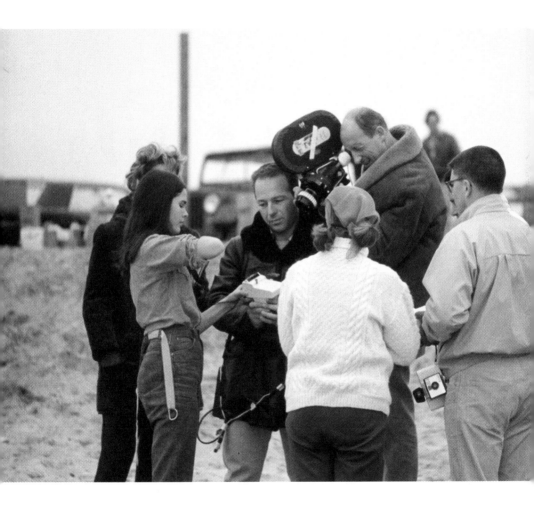

The Swinger's TV commercials
starred Ali MacGraw, not yet famous
(that's her in the blue shirt and
jeans). "It's more than a camera /
it's almost alive," went the jingle.

Chuck Close used the 20x24
Polaroid camera to produce immense
images of his own face, including
the breakthrough 1979 work
Self-Portrait/Composite/Nine Parts.

shareholders' meeting, one big new product was to be a large-format 8-by-10-inch film for professional photographers. Land got it in his head that he wanted to show off an even larger Polaroid. *Much* larger—one that made photographs that were 2 feet tall and 20 inches wide. Even crazier, the demonstration was three days away.

A team of engineers and technicians led by John McCann (of Miscellaneous Research; what could be more Miscellaneous than this?) worked through the weekend. A pair of giant stainless-steel rollers had to be turned on a lathe, their surfaces given a slight camber to make the goo spread properly, a task that required every bit of craft the machinists could summon. The rest of the camera was built out of whatever the Polaroid shops had kicking around, and the group made its deadline. On April 27, 1976, the giant emerged onstage.

It was a monster, nearly the size of a telephone booth and mounted on wheels, its accordion-like bellows capable of stretching out more than 2 feet. To pull the film out between the motorized rollers, one had to kneel before it and guide it with both hands, as if delivering a baby. A minute and a half later came the big revelation—the same peel-it-open-and-see moment, except that this photo was the size of a cocktail table. Onstage, Land and his crew shot a tight close-up of a fresh $2 bill, and later that day, Marie Cosindas made an amazing portrait of Candice Bergen, who was in Polaroid's TV commercials that year.

The results cannot be described in print, and can barely be reproduced on the page. Because the 20x24 (as it became known) camera's pictures were not blown up from small negatives, there is none of the loss of sharpness that is typical with big prints. In that photo of the $2 bill, you could see every fiber of the paper. A close-up of a face is perhaps six times life size. Pores and capillaries become practically topographical. Add to that the highly saturated tones of Polacolor, and you get a photograph that glows as if it's been plugged into a battery.

The Polaroid shops ultimately built five cameras to be gradually and strategically dispersed around the world: one in Manhattan, one in Prague, one in San Francisco, and so on. Elsa Dorfman, a Cambridge photographer, rented one indefinitely (and still has it) for her quirky portrait sessions. The New York camera, by dint of its location in the center of the art world,

got much of the work. A young artist and Polaroid employee named John Reuter became its minder, starting in 1980, and today he remains High Priest of the Giant Polaroid, Keeper of the Goo.

A small but extremely influential clique of artists began to embrace the 20x24, every one using it in different ways. In the early 1980s, Chuck Close was already well known as a painter of overscale self-portraits, usually rendered in pixel-like boxes. When using the 20x24, Close posed just inches from the lens of the thing, so that the big print showed perhaps 4 inches of his cheek or eyeball. Four or six or nine prints later, he had a wall-size composite picture of himself. If most 20x24 prints look battery operated, Close's are infused with rather higher voltage. Walk up close to one of them, and you see the color gradations in every hair of his beard, every sebaceous gland, the unmatched complexity of a human face's musculature and skin.

Starting in the mid-1980s, an artist named David Levinthal began making mysterious 20x24 photographs of posed figurines and artifacts, giving them the appearance of having strange inner lives. Some were ostensibly fun pop-culture items, like Barbie dolls and plastic soldiers, that took on mystery and a sinister edge when photographed this way. Others, like Jim Crow–era Mammy figurines, started out fraught and grew even more so before Levinthal's lens. That lens was often tilted slightly, to alter the depth of field and further tweak the scale of the subject. You're never quite sure, looking at a Levinthal print, whether you're seeing a tiny figurine photographed in close-up, or a full-size mannequin seen from a peculiar angle, or a living model in raking light. Your sense of perspective is thrown as these simple subjects become something new and unsettled.

And then there were the dogs. William Wegman had started his career as a painter and videographer, and beginning in the late 1970s, he turned his attention to one particular subject: his pet Weimaraners. In the 20x24 studio, he posed them in low-key ways that were at once antic and solemn: in sweaters, sitting with toys on their heads, covered in a heavy dusting of flour, curled up in come-hither poses. Wegman's 2005 retrospective was titled "Funney/Strange," and that's exactly what these photos are (the misspelling just makes them funnier and stranger). They're also harder to make than they may seem: The dogs' limited patience and

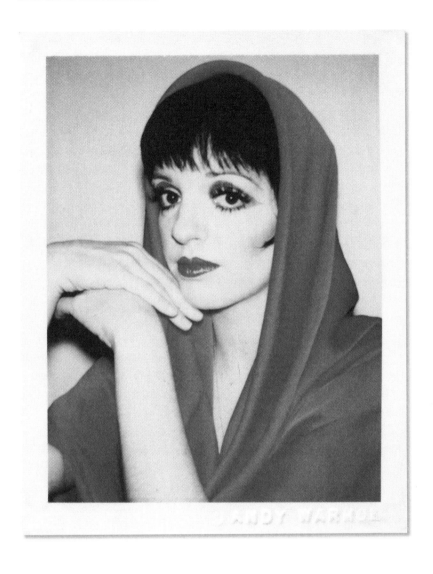

Andy Warhol shot thousands of celebrity portraits with his Big Shot camera, many of which became raw material for his paintings.

Andy Warhol, *Liza Minnelli*, 1977.
© Copyright 2012 The Andy Warhol Foundation for the Visual Arts, Inc./ Artists Rights Society, New York

the immobility of the huge camera make this a very difficult and expensive way of shooting. David Levinthal says that he and Wegman used to joke about who could shoot more 20x24 exposures in a single day. "I won, with about seventy-five or eighty," says Levinthal. "But Bill says that has to be with an asterisk, like Roger Maris, because my subjects don't move."

Andy Warhol spent time behind the 20x24 lens, too, but unlike most Polaroid artists, he preferred one of the junkiest cameras Polaroid ever made, a snout-shaped plastic thing called a Big Shot. It did not have a focus adjustment; it could only take a photo at a distance of about four feet, and was intended to shoot nothing but portraits framed from the waist up. (You'd "focus" by taking awkward half-steps, forward and back, in front of your subject, doing the "Big Shot Shuffle.") Warhol toted this thing to parties, to art openings, to museums. Before he painted portraits, he'd have the subject sit for a few dozen pictures, then choose one as the basis for the painting. The distinctive Warhol portrait we all know—a high-contrast silkscreened face, daubed with transparent color—comes out of these ordinary (yet extraordinary) Polaroid frames. There are thousands of them, too, and Warhol had unparalleled access to celebrity. Dolly Parton, Dorothy Hamill, Ted Kennedy, Arnold Schwarzenegger, models and rock stars and good-looking unknowns—they all posed before Andy's Big Shot.

The pack film that Warhol favored also encouraged a different kind of play. One day in the lab (the story goes), a technician peeled apart negative and positive, and lay the discarded half facedown on a lab bench. When he removed it, he saw that the dyes had transferred to the countertop. Soon enough, photographers began to make a virtue of this "problem": They'd peel the still-developing packet after only a few seconds, discard the photo paper, then lay the negative on a textured surface—often dampened watercolor paper—and press it down hard. The dyes transferred not as a crisp photo but instead as a soft, sometimes broken image, one that had watery tones and the quality of something old and slightly haunted. In the right hands, particularly John Reuter's, it produced stunningly beautiful work. Other manipulations presented themselves, too. Submerging a print carefully in hot water, for example, caused the image itself to float off its paper base, where it could then be teased onto a sheet of glass or

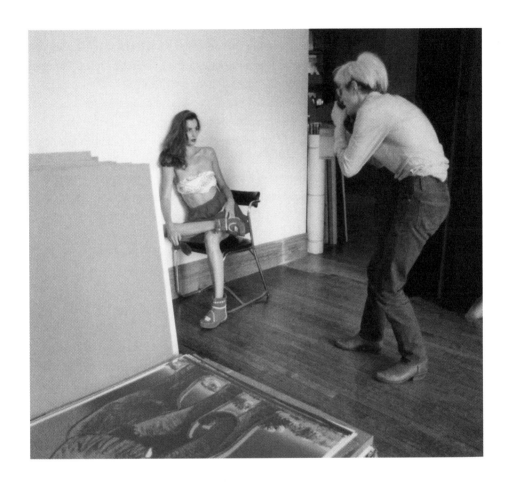

Warhol at work with his Big Shot,
1982. The subject is Apollonia van
Ravenstein, a star fashion model of
the 1970s.

porcelain, producing a distorted, gauzy photo, sometimes wrinkled and twisted as if it had been shot on Saran Wrap rather than film. These came to be called "image lifts," and every one was utterly one of a kind, its texture irreproducible.

The 20x24 was the mega-camera that lots of photographers wanted to try, but even that giant was not the largest one Polaroid built. That honor goes to another project from 1976, when Land headed into Miscellaneous Research and said to John McCann, "I would like to see a life-size reproduction of Renoir's *Le Bal à Bougival* [in the Museum of Fine Arts, Boston]. It's 39 inches across, and our film is slit at 40 inches—we can do it!" The result was not so much a camera as a portable knockdown room—a walk-in closet, assembled on-site at the museum, in which giant film was unspooled along one wall and held in place by suction from a Black & Decker vacuum cleaner. They *could* do it, as it turned out, though the Museum Camera (nicknamed by one user Moby C, in honor of that other New Bedford whale) was a bear to use, requiring two assistants inside, working in darkness with night-vision goggles. The lens alone weighed fifty pounds.

Renoir was only the beginning. Polaroid began photographing fine art of all kinds with this camera, and started a side business selling what it called the Polaroid Museum Replica Collection. Since the paintings were shot at actual size, there was no enlargement, and thus no concomitant loss of detail. You could see every brush stroke, every woven fiber of the canvas. When the Museum Camera produced portraits of people rather than paintings, they came through at life size, since a 40-by-80-inch print comfortably frames a large human being. If Land thought of his company as the place where art and technology met, this almost ridiculous instrument was absolutely at the center of the crossroads.[3]

Meroë Morse would have doubtless loved to see the giant cameras in action, but she missed out. By the late sixties, she was losing a fight to cancer. She kept working, as many driven people do, right up to the last weeks of her life, and when she died, in 1969, Land was in her hospital room, sobbing on her sister's shoulder. He had lost one of his scientific soul mates. McElheny notes that Land kept her private office largely intact, as a place for visiting researchers to work.

3 The 40-by-80 camera saw its last major work after the 9/11 attacks on New York. A photographer named Joe McNally was commissioned by Time Inc. to make portraits of firemen, cops, and other first responders. Since then, the stock of 40-inch-wide film has run out, and the camera has gone dark, probably for good.

Of all her achievements, the most lasting may be the art. After Morse's death, the Polaroid Collection of fine art photography grew into something huge, including prints—many but not all of them Polaroid pictures—by nearly every significant mid-century photographer. It eventually outgrew the labs (and Miscellaneous Research, where it ended up for a while), and passed to the corporate-communications department, where a Dutch executive named Eelco Wolf took it over. A committee of about a dozen employees oversaw purchases, each with the power to buy independently, a system that encouraged wide-ranging and quirky acquisitions. Aided by his counterpart in Europe, Manfred Heiting, and an administrator named Barbara Hitchcock, Wolf saw the collection grow to more than 20,000 photographs, with separate American and European divisions. After he moved on, eventually becoming the head of the Magnum Photos agency, Hitchcock became the collection's curator, right up through Polaroid's two bankruptcies and even for a while after that. It came to incorporate photos by kids, by scientists, by random Polaroid employees, by people as famous as Walker Evans and Andy Warhol. It ended up becoming not just a fine-arts treasure trove but also a fascinating depository of anything that anyone did with instant film.

Image lifts, in which the photographic emulsion was floated off its paper backing, turn straight-up photographs into three-dimensional work. In this one, by Christophe Madamour, you can practically feel the splash.

David Hockney's collages, like *Sun on the Pool, Los Angeles April 13th 1982*, would have been almost impossible to make without instant film—a misaligned frame could be reshot in the moment, instead of days later.

5 Ultimate Expression

In 1970, Land stood before a movie crew in an empty factory outside Boston, and (without a script) described the deep future of photography. "We are still a long way," he said, "from the…camera that would be, oh, like the telephone: something that you use all day long…a camera which you would use not on the occasion of parties only, or of trips only, or when your grandchildren came to see you, but a camera that you would use as often as your pencil or your eyeglasses." It was going to be "something that was always with you," he said; and it would be effortless. Point, shoot, see. Nothing mechanical would come between you and the image you wanted. The gesture would be as simple as—and here he demonstrated it, reaching into his coat—taking a wallet out of your breast pocket, holding it up, and pressing a button.

His future is our present, and what he's describing, pretty nearly, is a smartphone. In 1970, however, the only place you'd see such a thing was in a rerun of *Star Trek*. The Polaroid pack-film system did let you see what you'd shot, more or less immediately, but it took practice. The camera was chunky, with a focus mechanism that demanded a certain amount of squinting. The minimum time between shots was about fifteen or twenty seconds, and that was only if you were quick and smooth. Pull either of the paper tabs out too quickly or too slowly, and you'd damage the picture. A little breeze, or some beach sand stuck to damp new photos, would mean more time spent fussing with gear than taking pictures.

Once you were done shooting, the peeled-off film packet became trash, its face covered with sticky, caustic stuff that you were warned to keep away from your skin. The National Park Service was rumored to be dealing with piles of Polaroid rubbish, and anti-littering admonishments

were soon printed all over the company's film packaging. Polaroid lore has it that Lady Bird Johnson, the First Lady known for her Beautification campaign, personally asked Land to come up with a system that didn't produce so much garbage.[1]

Millions of consumers had accepted these little annoyances. Land the corporate leader knew that. But many of them tired of the rigamarole after a year or so, and started shooting less and less film, perhaps because they subconsciously wanted something simpler. (The marketing people called this problem "decay.") Land the perfectionist-aesthete wanted a self-contained system. It needed to be small enough to be carried everywhere, with no timing to screw up, no awkward trash, and certainly no double-pull-tab system. That last detail had been what computer jocks call a "kludge," a patched-together solution that got the job done but lacked grace.

As early as 1944, Land had told Bill McCune what he really wanted to build, and it had nothing *but* grace. McCune never forgot the conversation, recounting it five decades later in an oral history for his local public library in Concord, Massachusetts: "I remember very well…he said, 'You know, I can imagine a camera that is simple and easy to use. You simply look through the viewfinder and compose your picture and push the shutter release, and out comes the finished dry photograph in full color.'" Twenty-odd years later, it seemed both wildly advanced and within reach. Integral film, the idea came to be called, because the picture packet stayed together in one piece.

The project really got going in the mid-1960s. Called "Aladdin" at first, soon enough, the old project code SX-70 was dusted off and applied to the new baby, though Land dithered for years about the final name. At one point he considered calling it the Penultimate, to imply that there'd always be a better product to come. In the end, in a burst of nostalgia for his original inspiration, SX-70 stuck.

Land wanted the camera to be petite and neat, and he knew exactly how petite and how neat. In 1965, he went to one of his top engineers, Dick Wareham, with a wooden box that had contained an expensive Cross pen. It measured about 3.5 by 6.5 inches, like a chunky paperback. The camera should be *this* size, Land told them, and the photographer will hold it

1 The Johnson presidential library in Austin has no record that the First Lady actually did so. However, the archives do include a letter from a group called the Governor's Commission on Arizona Beauty, addressed to Land and cc'd to Mrs. Johnson. Best line: "The brilliance which was applied in perfecting your many fine products, we know, can also be applied to adequate disposal of the remains."

vertically, in front of his eye, and click the shutter. Why that size? It was to fit in a coat pocket, so you'd carry it with you often and easily.

The only way to expose an instant photo in a box that small was with a scanning mechanism, where either the lens pivoted to sweep its image across the film or the film slid past the lens. In about six weeks, Wareham and two of his engineers, Al Bellows and Leonard Dionne, cobbled together a prototype out of a packfilm camera back and other borrowed parts, and on the last day of 1965, they shot the very first color picture in the new SX-70 system. It shows Dionne in Wareham's office, bearing the quiet smile of a guy who has just figured out something tricky.

The very first SX-70 color print. The man in the photo is engineer Leonard Dionne, and his colleague Al Bellows snapped the photo; hence their "Len's and Bellows' unit" joke.

It turned out that a scanning camera wasn't the magic machine that Land had been hoping for. Keeping the shutter open for the lens to complete its sweep meant very long exposure times. Fluorescent lights, which flicker, left stripes on the picture. If the photographer moved even a tiny bit during the scan, vertical lines in the photos showed wiggles. Ordinary flashes didn't work right either. "We were learning about scanning, and it turns out that scanning had a whole lot of optical deficiencies," Bellows recalls. "We worked on that camera for a year and a half before we gave up."

To replace it, Land settled on a single-lens reflex, or SLR, design, which was no less complex. An SLR is the type of camera favored by the majority of serious photographers, because the view through the eyepiece comes directly through the lens—the photographer sees exactly what the camera does. An SLR usually includes a big, heavy prism and a hinged mirror, to bounce the image up to the viewfinder, adding weight and expense. The large Polaroid film sheet, about 3 inches square, required a correspondingly large mirror, and all of it somehow had to fit into the space defined by that wooden pen box.

Land had been thinking about an SLR for a long time. In 1960, he had even asked Henry Dreyfuss, the great industrial designer behind the classic Bell telephone, to sketch one out, though it never went into production. Now Land was at it again, this time with integral film. The ultimate solution was a folding camera, designed by Wareham's team, whose body sprung open like a little tent. A pair of mirrors, one curved, one flat, reflected the image up to your eye, and an extremely thin Fresnel lens—the kind with concentric rings that you see in lighthouses—focused the light; these lightweight components replaced the heavy, chunky prism of a standard SLR.

Dreyfuss's office didn't have that much to do with SX-70, but it did get deeply involved in at least one related project. It was to be called Polasound, and the idea was truly eccentric: to attach an audio caption to each Polaroid integral picture. The idea seems to have been that you'd clip your picture into a little plastic carrier that held a strip of audiotape. For recording and playback, you'd pop each one into what looked like a small radio with a slot on top. The gizmo never got past the drawing

board, but it's one of the most bewitchingly weird notions Polaroid ever considered.

One person who wasn't involved in SX-70 was Bill McCune, who by this time had become the company's head of engineering. McCune, as ever functioning *in loco parentis*, had expressed concern about the immense commitment of time and development energy that this project was beginning to suck up. Land in turn saw his colleague's skepticism as a threat to his grand life's work, and shunted McCune off onto other projects.

Sometimes, Land's perfectionism worked to everyone's advantage. For example, he demanded that the camera be able to focus from an infinite distance all the way down to 10 inches, because so many photographers fail to get close enough to their subjects. Millions of Polaroid photos looked better as a result. Certain requirements—like the thinness of the camera when folded—also occasioned new technologies. You probably own a few consumer products that were assembled with micron-thick double-sided tape, which didn't exist until the SX-70's compactness made it necessary.

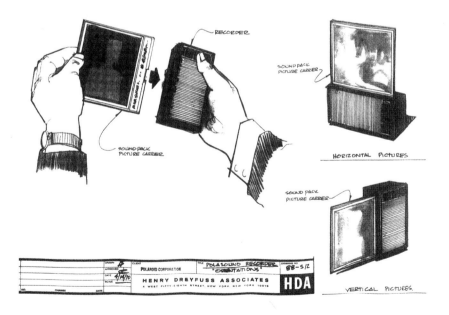

The great industrial designer Henry Dreyfuss drew up plans for a (somewhat wacky) plan to record magnetic data on each Polaroid photo.

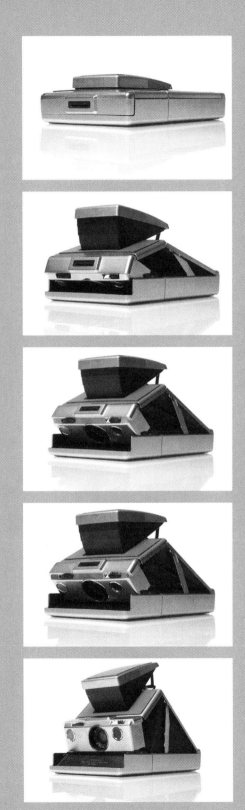

The final design of SX-70 folded down to the size of a cigar case, and could fit in a (largeish) coat pocket.

Other times, his insistence on purity overshot everyone's needs, both charming and maddening his executives and engineers. For example, Land wanted the view through the lens to be absolutely natural—no lines etched on the viewfinder, no sense of anything between photographer and subject. It was to merely frame your own view. Others at Polaroid argued for one of those little split-circle devices that allow you to adjust your focus finely. Nonsense, Land said: One should see one's subject as if just gazing at it, seamlessly. One should not have the experience of looking through a *machine*.

For most people, an unmarked viewfinder was not freeing but merely frustrating. Eventually, an engineer named Phil Baker said aloud what a lot of Polaroid's people were muttering—that the camera was just too hard to focus—and Land, after threatening to fire him, gave in and collaborated on a redesign. "I still don't like it. I understand we had to do it—thank you very much," he gracefully told Baker, as they finished up. "But I'm going to come up with something better." He did, too. A couple of years later, Polaroid brought it to market: the first widely available autofocus camera, one that measured the distance to the subject using a sonar ping. The sonar module had been awkwardly grafted onto the neat SX-70 body, and it looked a little clumsy perched atop the lens, but it worked extremely well, and the autofocus cameras probably are the ones that come closest to Land's "absolute one-step photography" dream of the 1940s: point, shoot, see.

Land also insisted that the panels of the camera body be covered in real leather. Its glass-fiber-reinforced plastic frame was heavily chrome-plated, giving it the appearance of brushed stainless steel while remaining warm to the touch. Never mind that the cowhide added several dollars to the production costs, and that natural leather's irregularities vastly increased the number of factory rejects. Land refused to budge, making pronouncements like "the camera deserves leather."

In the 1960s and '70s, this all cost a fortune, although nobody admitted in public how much. Estimates from outside Polaroid ranged from $250 million to $750 million. A lot of sources settle on $600 million. Al Bellows says he once heard, in-house, that Polaroid spent a billion dollars on the camera and another billion on the film.

Much of that money went toward several immense factories nobody had initially budgeted for. A plant to make the negative layer of the film, in New Bedford, Massachusetts, was one of the great industrial palaces of its time, pulled together by McCune and an engineer named Israel MacAllister Booth, whose reputation within Polaroid soared. "That plant…," John McCann says today, still sounding a little awed. "I guess Fuji has one like it somewhere, but there was nothing like that anywhere else in the world."

Other components were less technologically demanding but no less of a headache. Take the power source, for example. Polaroid research had discovered that many failed photographs were the result of a camera with dead batteries. So, the engineers thought, why not incorporate a new battery in every film pack? That way, every reload would rejuvenate the system.

The resultant 6-volt cell had to be flat and thin, and it had to hold its charge long enough to make its way from factory to warehouse to retailer to consumer. Reliably producing it was a solvable problem—or, as the people in Land's orbit began to say, an "opportunity"—but not an easy one. Polaroid subcontracted it to Ray-O-Vac, but ran into quality-control trouble and ended up bringing the job back in-house. Even afterward, some batteries outgassed fumes that tinted the photos blue. Like the coater problem back in the early 1950s, like the curling problem with Polacolor ten years after that, the battery fiasco was a small mess that got mopped up after the product was in stores.

At least batteries were a known technology. The three metalized dyes that produced the color image were all new. An SX-70 photo contained thirteen layers of chemistry, each knitted into the rest of the system. To take one simple example, the thin plastic sheet atop the image, like its corresponding dark cover on the back, needed to be flexible enough to go through the camera's mechanism but stiff enough to avoid crumpling. That front cover (ultimately made of Mylar) also had to be absolutely clear, because the film was exposed through it.

If the pod did not have to be peeled off and discarded, the new format would require a pouch permanently attached at one edge of the photo.

Bellows remembers fretting about it, because in the early prototypes, it sat above the image, unattractively. Then, at one point when he and Land were reworking the camera's geometry, Bellows noticed that the redesign had shifted the pod to the bottom of the photo, where it would look better and provide space for a caption. He went on to suggest that the positive layer inside the film packet be extended to keep the border uniform and flat. This set of benign-seeming decisions created Polaroid's definitive look: the white frame, wide at the bottom, that provides a handle if you insist on shaking your picture. The border turned out to be not ugly but lovable, and much later became an icon of a different sort—the kind you click on computer screens. Today, it means not just *Polaroid* but simply *photograph*.

For SX-70 to work, the picture had to be light-sensitive while inside the camera yet able to develop in daylight. That requirement led to maybe the most extraordinary bit of Polaroid chemistry of all: the opacifier. As a Polaroid camera spit out its photo, rollers spread its cocktail of developer over the negative, including a green-gray chemical that blocked out light. Over the next few minutes, as the dyes migrated through the white background layer, the opacifier protected the picture underneath. Then it turned from opaque to clear, unfogging the image.

It was nearly impossible to do. Land kept telling the rest of the engineering teams—those working on the rollers, the plastics, the optics—to just proceed under the assumption that he and a team led by one of his best chemists, Stanley Bloom, would get it there. On November 4, 1969, the opacifier finally passed its test, as a photo developed under two blinding sun lamps while Land, Bloom, and fifty researchers stood watching. As the image blossomed, they burst into cheers.

It's hard to explain the pleasing and wonderful weirdness of this process, in 1969 or for that matter today. Seeing your own face emerge out of the misty goop has the quality of a sleight-of-hand trick or a striptease: a slow reveal, one that keeps you guessing, then delivers. It all but compels you to stare, as if into a pond, straining to see whatever is swimming below the surface. It's hard not to watch.

It also provided an unexpected new form of artistic expression. The emulsion was based on gelatin, and it remained soft and gooey under its

Lucas Samaras turned the soft emulsion of an SX-70 print into a new medium, manipulating his own image in strange and extraordinary ways that he called "Photo-Transformations."

Mylar cover for several hours, and sometimes more. If you pressed on the surface with something hard, like a dull pencil, you'd distort the image. Before long, a great many people discovered that they liked messing with a photo as it appeared, even more than they had with image transfers and emulsion lifts. The artist Lucas Samaras had been doing odd things with Polaroid film for years, shooting weird self-portraits and tweaking a pack-film camera so that he could "paint" his subject with colored lights in the dark. Now he began to turn his SX-70 prints into wild things, doing new and unsettling (and completely one-of-a-kind) things to his visage.

Most practitioners of SX-70 manipulation took it in less intimidating directions, turning still lifes and pictures of flowers into soft Impressionist paintings. Image manipulation particularly caught on among art students, because it was low risk and potentially high reward. The photographer Storm Thorgerson created an album cover for British art rocker Peter Gabriel by manipulating a photo so half the musician's face appeared to be sloughing off.

Gabriel wasn't the only musician to start playing with the new medium. To make the cover of the 1978 Talking Heads album *More Songs About Buildings and Food*, the band's lead singer, David Byrne, posed the group's four members, including himself, against a blood-red back-drop and set up an SX-70 camera with a special add-on lens that focused only at full life size. He proceeded to shoot 529 photos that added up to an antic composite portrait on a square grid. "I liked the way distortions and mistakes were inherent in the process—no matter how much any photographer tried to make a perfect fit, the pieces always looked skewed," he recalled some years later.

David Hockney, the English-born painter best known for his brightly colored renderings of California life, also started making Polaroid collages. His works play even more dramatically with depth and scale than Byrne's do. Hockney saw the slight changes in perspective among these images as a form of Cubism; one even centers on a Picassoesque guitar. Another, titled *Sun on the Pool, Los Angeles April 13th 1982*, uses Polaroid's saturated color to invoke the azure of a SoCal backyard swim, and the rows of tiled photographs do dizzying things with the biomorphic shape of the pool.

For the cover of Talking Heads' album *More Songs About Buildings and Food*, David Byrne attached a close-up lens to his Polaroid camera and embraced the slight irregularity and imperfection of the results.

André Kertész, like Walker Evans,
reinvigorated his career late in life
with an SX-70.

Older photographers were also drawn to SX-70, in part because it was so easy to use. One was André Kertész, the Hungarian expat who, after forty years of on-and-off artistic endeavors, was by the 1970s finally beginning to see his influence recognized. When his wife, Elizabeth, died in 1977, Kertész was shattered, and barely able to work. His friend Graham Nash (of Crosby, Stills & Nash) gave him a Polaroid camera, and he began, slowly, to make small still lifes, often focusing on a pair of glass figurines posed in evocative, intimate settings on his windowsill. He spent six years working with SX-70, up until he died in 1985 at the age of 91. The pictures are simultaneously an epilogue to, and a view into, a long and complex marriage.

Walker Evans also closed out his career with a Polaroid flourish. By 1973, the legendary photographer of Depression America was infirm and essentially retired when he got himself an SX-70. Over the next fourteen months, he shot thousands of photographs, the last work of his life. "I bought that thing as a toy, and I took it as a kind of challenge," he explained to the editors of *Images of the South: Visits with Eudora Welty and Walker Evans*, published in 1977, two years after his death. The pictures he made in this final artistic burst are simple, exquisitely composed Americana: buildings with peeling paint, bits of signage, a crushed beer can submerged in a clear stream. "The damn thing will do anything you point it at," Evans marveled. "Nobody should touch a Polaroid until he's over sixty. You should first do all that work....It reduces everything to your brains and taste." He, fortunately, had both.

Integral film does, admittedly, have one technical drawback. The old Polaroid peel-apart product produces a photo that looks like a high-gloss print made in a darkroom. SX-70 pictures, because the dyes have to migrate through a thick layer of white pigment, are ever so slightly diffuse. They can look excellent, but they are almost never as razor sharp as their predecessors. You look into them rather than at them. They also have a distinctive, heavily saturated color that is absolutely their own. Especially the blue: Nothing looks like Polaroid blue.

In our time, that quality is almost touching. A Polaroid print looks so powerfully *analog*. After all, SX-70 and its later refinements were just about the last major technological leap in photography made before

the end of film. Something madly complex turns that flat little bag of wet chemistry into a full-color photo, and it's physical: The light passing through the lens produces the very image that can be held a moment later. It seems almost possible that, as certain premodern tribesmen reportedly believe, the camera steals a piece of its subject's soul.

SX-70 was unveiled teasingly and gradually, over a couple of years, with sneak peeks doled out carefully to industry people and members of the press. It might have taken even longer, but Land committed everyone to a big revelation at Polaroid's shareholders' meeting in April 1972. Peter Wensberg wrote in his memoir that six months' worth of product development were crammed into the six weeks before the event. Big stories in *Time* and *Life* bookended the introduction, and both magazines' cover photos perfectly conveyed the mix of shyness and heat seeking that characterized Land: In neither photo could you fully see his face, since he had a camera jammed up against his eye. But he was still the star.

Time's picture had been shot by the legendary Alfred Eisenstaedt, and Philip Taubman, the young reporter who was sent to interview Land, recalls that Eisenstaedt did not bring the usual team of assistants and cases of equipment. Instead, he showed up with a tiny Leica camera in his pocket, loaded with one roll of film. Land posed on the steps of Polaroid's headquarters; Eisenstaedt clicked off about ten frames and put his camera away. Land asked "That's it?" That was, indeed, it.

At the shareholders' meeting itself—held in a leaky old Polaroid warehouse in Needham, Massachusetts—a huge set had been built, with carefully lit octagonal stations where attendees could see the magic happen. Attendants whisked away cameras that jammed or photographs that didn't come out right. The pictures that did look good were pinned to oak ledges through holes punched in the white border, so they couldn't be grabbed by industrial spies. (One got out anyway.)

Polaroid also screened an eleven-minute film by the industrial-design gurus Charles and Ray Eames. Titled simply *SX-70*, it's a lovely period piece, principally because it mixes two qualities that we rarely see joined today: It is enthusiastically pro-technology, and it is very quiet. Set to a lilting flute-and-piano score by Elmer Bernstein, the film opens with a quick rundown of the history of photography, and segues into

Charles and Ray Eames's film was the perfect Polaroid promotion: hovering right on the line between brainy advertisement and ode to a new way of seeing.

an explanation of how to use the camera, then to a startlingly technical
description of its mechanics and film chemistry. As the picture-taking
starts, children cavort before the lens, researchers make photographs of old
engravings, and people take quiet snapshots at the New England seashore.

At the end, everything wraps up with an essayish riff by the great MIT
physicist-philosopher Philip Morrison. "You can look at technology as a
living tree, a trunk bearing branches, the branches leafing out," Morrison
says, as we see softly composed arrays of cameras and lenses being
assembled at the Polaroid factory. He continues:

> Or you can see it as a net, each knot tying up threads from
> many sizes. But the human reality is more intricate than
> either one. We have been looking at one invention which
> began pretty purely, out of the conception of a need:
> the hope to change the person who takes pictures from
> a harried offstage observer to a person who is a natural
> part of the event.... The device helps meet the universal
> need to do things well. It offers as a matter of course a tool
> for supplying a rich texture to memory. More than that,
> thoughtful use can help reveal meaning in the flood of
> images which makes up so much of human life.

It's worth lingering on this little movie for a reason: It is a perfect
encapsulation of the Polaroid view of the world. It mixes self-conscious
artiness with intense technological talk. It risks going over the heads of
viewers, to a degree that an adman would consider insane. It is relent-
lessly explanatory, but a very soft sell despite its enthusiasm. It reflects
Land's view that if the product was right—not just economically, but also
morally and emotionally—the selling would take care of itself. "Marketing
is what you do if your product is no good," he once put it. Another time,
when a shareholder questioned how much he was spending on product
development, he was even more dismissive: "The bottom line," he said,
"is in heaven." Romantic utopianism lay at the very core of what was soon
to be a billion-dollar business.

In 1974, he published a sweet little booklet of instant photographs,
many of them his own, and in its introduction, Land went so far as to claim

that the SX-70 had the power to heal all the rifts in contemporary life. Here's what he had to say (in one sentence!):

> We would not have known and have only just learned— perhaps mostly from children from two to five—that a new kind of relationship between people in groups is brought into being by SX-70 when the members of a group are photographing and being photographed and sharing the photographs: it turns out that buried within us— God knows beneath how many pregenital and Freudian and Calvinistic strata—there is latent interest in each other; there is tenderness, curiosity, excitement, affection, companionability and humor; it turns out, in this cold world where man grows distant from man, and even lovers can reach each other only briefly, that we have a yen for and a primordial competence for a quiet good-humored delight in each other: we have a prehistoric tribal competence for a non-physical, non-emotional, non-sexual satisfaction in being partners in the lonely exploration of a once-empty planet.

That's a tall order for a camera. But is it any less modest than the claims being made for the Internet today? Connection, humanism, and intimacy above all. And he's particularly right about kids, who immediately grasp the wonder of instant pictures.

Land's philosophical turn of mind was extremely good for his scientists and for the company's pure research. It could also make him a very difficult man to confront, to argue with, to persuade. When your boss is saying "the camera deserves leather," how do you tell him it's not cost-effective? The bottom line, after all, is in heaven.

When it comes to beautiful extravagances, everyone seems to remember the tulips. It was shortly before the 1973 annual meeting, soon after the full rollout of SX-70, and Eelco Wolf got a call asking him to come to Land's office. "You're Dutch, right?" Land asked. "We need 10,000 of these," and handed him a tulip of a variety called Kees Nelis. (It was vibrant yellow and red, the colors that looked best on the early SX-70 film.) The

meeting was just a few weeks away, and Wolf had to immediately find a farmer who was willing to accelerate his crop to hit the deadline. Then he had to strike a further deal with KLM Royal Dutch Airlines to air-express the buds from Schiphol to Logan, where they could be rushed to the meeting. All the resulting photos of flowers were, of course, lovely. It was another unforgettable Landian demonstration, this one at god-awful expense.

The company projected sales of one million SX-70 cameras in 1973. Its factories were able to produce half that many. List price was $180; the film cost almost $7 a pack. Some dealers were charging more than $300 per camera, and getting it. (One of those dealers bought himself a boat with the windfall, and named it *SX-70*.) Polaroid even managed to sign up Sir Laurence Olivier to do the television ads, the only ones he ever made.

The people who still didn't embrace SX-70 mostly worked on Wall Street. Land had simply blown through too much money, by their calculations, and they began to say that Polaroid's stock was finished as an investment vehicle. From the early 1960s until 1972, the company's share price had more than quadrupled. At the splashy SX-70 introduction, it spiked again, to a high of $149.50. Then the reports started coming in: of battery problems, of camera shortages, of flawed film. Bill McCune later revealed that 300,000 cameras came back for repairs and alterations. A dealer claimed that one film pack out of ten had a bad battery. At the same time, the oil-shocked economy of the United States went into a dive. Stocks were falling, even strong ones. By July 1974, Polaroid's share price had dropped more than 90 percent. Wall Street had bet that SX-70 was a technological overreach and a business failure. A story in *New Times* called it "the Edsel of the 1970s."

It wasn't, but for the first time, people had grumbles about Land: that his ego had got the better of him, and that his overspending had been irresponsible. Land, for his part, blamed the marketing department, insisting that people simply had to be educated about how to focus an SLR. In January 1975, he was so peeved about Polaroid's advertising—it didn't spend enough time on instruction, he said—that he sent a terse memo to Ted Voss, saying that if new ads were not forthcoming, Polaroid would be seeking a new agency. DDB promptly produced another set of

Marie Cosindas, Ansel Adams,
and Bill McCune pose at a
Polaroid reception.

commercials starring Candice Bergen, who explained in fastidious detail how to focus the camera. The great demonstrator was working by proxy this time.

What really kept Polaroid going through the crisis was its old, known technology. Land grudgingly let Bill McCune back into the SX-70 realm, needing his quality-control expertise, and in doing so just may have saved the whole thing. Pack-film cameras continued to sell—more than four million per year in this era—and Polaroid added a couple of inexpensive models at the bottom of that line to boost income. McCune, the pragmatist, pushed for budget versions of SX-70, with cheaper plastics and vinyl in place of the leather. Land set himself to, among other things, improving the film chemistry and working on the sonar autofocus system. It turned out to be a tense but effective collaboration. A project this size needed pragmatists who were not averse to dreaming, and dreamers who could also get things done. Land and McCune fought, but the push-pull of their relationship had its benefits.

Slowly, with pressure from both sides, the ship righted itself, and by 1975 it was picking up speed. The batteries finally worked. There were enough cameras in stores. Within a couple of years, Polaroid reached $1 billion in annual sales. SX-70 was no Edsel: It was the Ford Mustang, a product that changed the business. Even Andy Warhol gave up his Big Shot for one, after a little prodding from Ted Voss's marketing group.

The recovery came just in time, too. Since the late 1960s, Eastman Kodak had been watching the goings-on in Cambridge with a sense that they had missed out on something—that instant photography was not a gimmick but a major part of the future of picture-taking. Had they given it away by making all those negatives? Polaroid had begun to hear disturbing rumbles about Kodak's plans: a full-on push into the instant field.

There was another project going on at Kodak in 1975, too. An engineer named Steven Sasson had worked it up as a curio, with little expectation that it would ever be made public. It was a new camera, built around not a sheet of film but an electronic sensor, one that recorded its image on magnetic tape and displayed it on a TV screen. It was no pocket camera but a desktop hulk that looked a little like a slide projector. When he presented

it to colleagues, Sasson called his invention "film-less photography." The words "digital" and "camera" hadn't been put together yet. But that's what it was.

As it turned out, the two Kodak projects had exactly the opposite effects everyone expected. Instant film became not a moneymaker but rather one of Kodak's great humiliations. The digital camera was going to change everything.

In October 1980, director Francis Ford Coppola demonstrates a gift he's presented to Japanese director Akira Kurosawa: a case of Polaroid's new Time-Zero film. That's George Lucas looking on, amused.

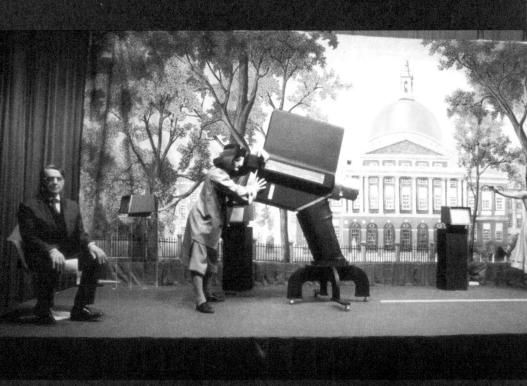

Land demonstrates Polavision for the
shareholders, April 26, 1977.

6 Fade In, Fade Out

The *New York Times*'s 1947 story about Land's first demonstration to the Optical Society of America is dead flat in tone and thorough in scope. In seven brief paragraphs it lays out the whole system: rollers, pods, one minute between click and image. Then, in the last sentence, comes a curveball: "The new processes are also inherently adaptable for making pictures in color and for motion-picture cameras."

Motion-picture cameras. Land himself must have mentioned it, because few reporters would have asked. It made sense, though. Instant filmed images would have huge value in the newsreel business. Home movies, too, were becoming commonplace—why not see those right away, too? Land envisioned people documenting their families' lives, day in and day out, and instant movies would foster that like nothing else.

To that end, in 1961, a good two years before he'd sold a single color print, Land had initiated research on instant movie film. It was to utilize a system called additive color, which requires a little explanation. A printed color image is usually formed with four inks: cyan, magenta, yellow, and black. The first three colors are each a mixture of two of nature's primary colors, and each absorbs the third. Cyan, for example, is made of yellow and blue, and absorbs the other primary, which is red. If you put a denser layer of cyan ink into a printed picture, that picture appears less red; take the cyan out, print with just magenta and yellow, and you get fire engines, cherries, ruby lips. This arrangement is what's called subtractive color: the cyan ink is meant to drink up red light rather than reflect it from the page to the eye. This book was printed with a subtractive-color system. So are magazines and color photo negatives; so were Polacolor and SX-70.[1]

1 One major exception is television, which uses three illuminated dots, in red, green, and blue, to produce each pixel of color onscreen.

Subtractive color is not perfect. Mixing magenta and yellow dots on the page to produce red isn't the same as printing with red ink. It stimulates the eye and brain similarly, but it doesn't have the true intensity of an additive system using three actual dyes (red, green, and blue). The same goes for subtractive movie film: a green-sensitive layer forms magenta dyes, which block out magenta light and create green images. But that's not like shining a bulb through a green film to get a true, bright, grassy green.

Why don't we all make pictures in additive color? Because the dyes that render those tones so accurately have to be overlapped and mixed to show various shades, in layers that can end up very dense. Put all three dyes on a strip of movie film, and you end up with a heavy, dark image that's difficult to project across a room. It had been tried: The earliest experimental color systems, at the end of the nineteenth century, were additive. One, called Dufaycolor, available as early as 1908, was briefly popular until Technicolor won over its customers. George Eastman had also taken a stab at additive color, and had not been able to commercialize it.

Now Land thought he could. The project was called Sesame, which paired nicely with Aladdin, and he gave the project to Lucretia Weed, the latest in his line of favored young Smith women. Sharp and independent, she'd arrived at Polaroid the Monday morning after she dropped off her cap and gown in May 1959. She had no training as a chemist. "I was an art-history major!" she says today, sounding a little amused. "[Land] felt that, if you had all this *whatever*, how could you invent something?" She didn't have *whatever*, by which he meant the calcified knowledge that can sometimes smother fresh thinking, but she had intellectual rigor and a clear head, and what a colleague approvingly calls "a positive sense of dissatisfaction." And she worked like crazy. Land once figured out that if he counted all her overtime and weekends, she'd been in his employ for sixty years. (In fact, it was twenty-two years, plus another eight after Land retired.)

What she and her team, aided by occasional drop-ins from the boss, came up with was a film like no other. On the surface was a black-and-white negative, so thin that it essentially disappeared after processing. "It had to have very minimal amounts of silver so it would show through,"

says Weed. Beneath that lay tiny bands of dye, alternating red-green-blue, red-green-blue, 3,000 to the inch. It was murderously complicated to manufacture. Inside Polaroid, the operation was called the Land Line.

The result produced accurate, bright color, but it was, indeed, a very dense film. It had to be shot with bright lights (its ASA rating was only 40). You couldn't project it across a theater, or even a living room, but that had always been a problem with home movies anyway—they had stayed an enthusiast's medium because they were cumbersome. Nobody really enjoyed setting up a movie screen.

The solution to both problems was a self-contained viewer. It looked more or less like a portable TV set with a slot on top. Film was contained in cassettes. Once you'd popped one into the camera and shot it, you'd take the cartridge out of the camera, drop it into the player, and rewind it. And here was the bit of Landian eloquence, the *aha!* moment: As the film rewound, it popped open a tiny pod of chemicals ("twelve drops," Land used to say) and spread them over the ribbon of film. By the time the cartridge was done rewinding, it had been processed and ready to go, and the liquid had evaporated.

The system, named Polavision, made its debut in 1977, and was not without its charms. The cameras, manufactured by Eumig in Austria, were small and light if a little dated-looking. Polavision was neat. It was easy to use.[2] The commercials starred Danny Kaye, one of the most beloved figures in American pop culture, and Tony Roberts, then at the height of his *Annie Hall* success. The whole thing was introduced with a big fanfare at the annual meeting. This year, though, "the sudden recognition of an inevitable idea was missing," Peter Wensberg wrote. The price seemed troublingly high, at $675 for the basic setup. And then the querulous questions started: What about sound? (We're perfecting it, said Land.) Haven't you spent too much on this project? ("The bottom line is in heaven.") And, most of all, *What about videotape?*

Two years earlier, Sony had introduced its successful Betamax, and at first glance, it looked like a decent horserace between the two technologies. The Sony camera was a much bigger and heavier thing, tethered by a cable to a tape machine that you slung over your shoulder with a strap. Polavision was considerably cheaper than Betamax, and color film still

2 For most people. The actress Brenda Vaccaro was at first hired to do some of the ads, and got a preproduction camera to try out. "She took it to Central Park and lost it," Sam Yanes recalls, laughing at the memory. "She was a little out of it."

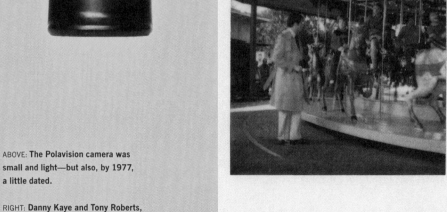

ABOVE: **The Polavision camera was small and light—but also, by 1977, a little dated.**

RIGHT: **Danny Kaye and Tony Roberts, photographed on the set as they filmed their Polavision TV ads**

looked crisper than color TV. But once you put the camera down, video had big advantages. Polavision's cassettes were three minutes long; Sony's held an hour, and were soon expanded to two. A Betamax VCR could record TV programs as well as live images. Its magnetic tape could be reused almost indefinitely. Polavision was silent; Betamax had sound. Videotape was easy to copy at home.

Inside Polaroid, a lot of people quietly feared that Polavision might not be a winner. McCune had been against it, but he sensed that Land could not be deterred. Stan Calderwood, initially a Polavision enthusiast, had soured on the project before leaving Polaroid, telling Paul Giambarba: "The goddamn movie-camera business accounts for only 3 percent of the entire photographic market, and Land insists on getting into it." Certainly that was true, possibly because making a movie with extra-bright lights is much more disruptive than taking a photo.

There's also a subtler difference at work. Much of the appeal of instant photography is that it draws people together. It's an icebreaker, a conversation-starter. None of those qualities made their way into Polavision, because viewing was tethered to the player. You had to go to it; it didn't tag along with you. At best, you could troop all your party guests over to the screen so they could watch three minutes' worth of film, but that didn't fit into the way we naturally behave, as instant pictures had. Polavision did not fulfill Jennifer Land's demand: "Why can't I see the picture now?" If you were at a picnic or a grandparent's house, you couldn't see it, not till you got home.

In the past, Land had pushed his company to produce new products at the very edge of what the market might bear. Every big bet, from the sheet polarizer through SX-70, had required a leap of faith, a trust that the genius-in-charge was right. "He's never been wrong before," people seemed to be saying, "and he's made us all rich. He must know something we don't."

At least one outsider knew better. Shortly before Polavision came to market, Akio Morita, the founder and chairman of Sony, a good friend of Land's—in many ways his Japanese counterpart—paid a call in Cambridge. A demonstration was arranged, and John C. Goodman, a physicist and engineer, was charged with making sure the player worked. "The capstan

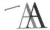

AA ANSEL ADAMS THIS IS MEMO 3045

ROUTE 1, BOX 181, CARMEL, CALIFORNIA 93923 TELEPHONE (408) 624-3558

December 24th 1977

Dear Ted Voss,,

Following my last letter about ideas for obtaining demonstration cassetts for Polavision:

My assistant, Alan Ross, and two friends remarked that they had been to Macey's (our leading department store, and really large establishment) and had seen Polavision displayed on the counter between cameras and portable radios, etc.

It was "statically" there complete, but unattended and quite "dead". Nobody was paying any attention to it; it looked like a small TV set. They all said to me "How do they expect to sell a $700.00 outfit with THAT kind of display"?

I fear this approach is going to be costly and discouraging. There is plenty of money in this area; people buy expensive cameras and TVs and I am sure there would be a response to Polavision.

I do not know what happened elsewhere. I do know this - that without seeing a picture on the screen, Polavision means little to most people. The dealers take flash pictures with the other Polaroid cameras and these usually make sales - or, at least, stir conviction.

While I sent on the best cassetts I had to Polaroid, I still have a few here that are 50% OK- that is, there are some pictures that are good; the others represent boo-boos, high contrast, poor color (in shade), etc. Now that I know a little more about the process I can make a reasonably consistent reel - but without editing it is a real challenge to produce something that would be convincing to the potential buyer.

That is why I suggested art, photo, and cinema departments in the various schools, because they should welcome an opportunity to present a challenge to the student.

I did quite a few cassetts of some huge waves we had here but the contrast was too great and the surf burned out. The exposure-range is very short. When subject-contrast range is just right the effects are remarkable and the color beautiful. Obviously, it works better in the relatively soft light of the east than in this rather contrasty western sun-and-shadow..

I have not had enough film (or opportunity) to study controls, but I feel we should have a Light-balancing filter (and perhaps a few CC filters

ANSEL ADAMS Ted Voss PAGE 2 DATE: ____12-24-77____

to help out with certain conditions. Any filter of consequential density would need its counterpart for the "eye"

One simple (but important) point that we have found - there is no place to "store" the little plastic "screw" that, when inserted, removes the internal filter when pictures are to be made with tungsten light.

It should have been designed to fit the second hole in the Zoom ring; once the customer has placed the Zoom rod where he wants it, this screw could be inserted in the opposite hole. I will wager that these little blac screws are going to be lost in quantity!

The film I used was mostly of "seconds" quality. I have none left now; had a few of "good" quality which I used for the cassetts I made for the LA presentation (got one fairly good one - but nothing to get me an Oscar!!)

I am going through all the cassetts, make notes on them and return them for whatever good they may do. I am sure that all the points I can discuss have already thoroughly been through your technical "think-tanks!"

The process has GREAT potentials in many directions. I hate to see it depreciated by inadequate presentation and sales. Maybe I am being too rough? Maybe there have been many examples of excellent display? I am only reporting what I know.

HAPPY NEW YEAR!!!!

In a long memo he sent back to Cambridge, Ansel Adams registered his agitation that Polavision wasn't being demonstrated and sold well—but admitted that he hadn't had great success using it himself.

kept slipping," he recalls, "so to keep the thing going, we had to keep spraying stickum on it every time [the film] would roll through. So we were hiding under the table, being as inconspicuous as possible." The film ended, and the lights came up. Land asked Morita, "Well, what do you think of that?" Morita responded, "Ahhhh... well," then paused. "You can sell 50,000 of anything." Morita went on: "It is an unbelievable scientific development. But you are too late."

It was too late to bail out—as if Land would even consider doing so— and the marketers did their best. They spent $5 million on advertising. Ansel Adams puttered around with the system, making films of waves at the California shore. ("Got one fairly good one—but nothing to get me an Oscar," he wrote to Ted Voss.) The Eameses shot several little Polavision films, and Andy Warhol and his pals documented the goings-on at his Factory. John Lennon's home movies of Yoko Ono and their son, Sean, are Polavision films. Nonetheless, the number of buyers couldn't begin to cover the development costs. Sales, projected at 200,000 systems, started sluggishly, then slowed down. The failure helped send Eumig, the camera contractor, off into bankruptcy. An exact total is hard to come by, but Polaroid probably sold about 60,000 systems. The true development cost is similarly hard to suss out, but most sources say it was $500 million.

Polavision stumbled along until the summer of 1979, when the hardware was discontinued (though film cartridges stayed on the market for several years), and the ledger showed a $68 million writedown—not enough to cripple Polaroid, but still a lot. Land was defiant, first trying to arrange for an extra marketing push, and then making a last-ditch demonstration to his own board, showing off the competition's awkwardness and bulk.[3] Even that board, largely stocked with his admirers, said no. For the first time, Land's ego and high-handedness were not backed up by a perfect sense of what people viscerally wanted.

Morita was right: The project had simply taken too long. Polavision, when conceived in the 1940s, was otherworldly. In the early 1960s, when the additive-color-film research began, it was still revolutionary. If Polaroid had been able to get it to market in 1965, it would've been the gadget of the year, and a lot of baby boomers would probably have grown up with a drawerful of Polavision cassettes instead of Kodak Super 8 reels.

3 This involved hiring door-to-door salesmen to sell Polavision, on the theory that Landian demonstrations would prove its superiority. Polaroid went so far as to sign a contract with Electrolux, the vacuum-cleaner manufacturer that sold its products the same way.

Andy Warhol, seen at a party in Boston on Polavision film. The fellow in the red checked shirt and dark jacket is Ted Voss, Polaroid's worldwide marketing chief.

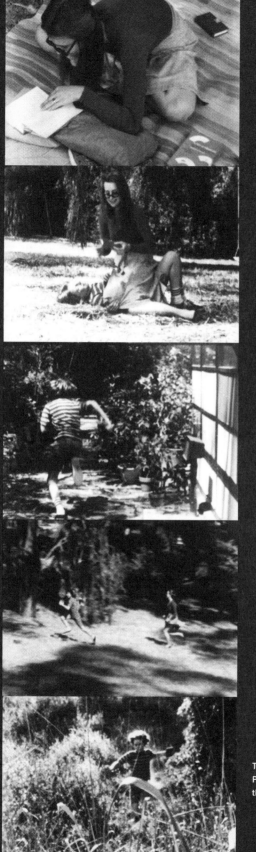

The Eameses had fun with Polavision, too, shooting vignettes that involved their daughter, Lucia.

Land's perfectionism and the distractions of SX-70—and his stubbornness about hanging onto an idea as the world changed around it—kept the project going for another dozen years. An ordinary CEO most likely would have bailed out; then again, an ordinary CEO wouldn't have had the idea to begin with.

Interestingly, a parallel disaster was happening at one of the mightiest corporations in America. In 1964, research had begun at RCA's laboratories in Princeton, New Jersey, on a machine that could play television programs from a prerecorded disc. Inexpensive lasers (which later made CDs possible) were not yet available, so RCA's system used a stylus that tracked a variable-depth groove. The electrical capacitance across the tiny, changing gap between needle and disc stored the TV signal. It was about as audacious a technological idea as 3,000 lines of colored dye per inch.

RCA's disc player came to market in 1981, under the name Selecta-Vision—it even sounds like Polavision!—and it too got clobbered. Japanese-made VCRs, which were already widespread, could record as well as play. (Also, if you touched a SelectaVision disc with your finger, you'd ruin it.) RCA's management had believed that its player would be far less expensive than one using magnetic tape. They didn't count on the dazzling ability of Japanese electronics companies like Sony to make products smaller, cheaper, and more refined, and do it swiftly. SelectaVision bumped along weakly until 1986, when an enfeebled RCA, once the most powerful company in consumer electronics, was bought by General Electric and dismantled.

These years marked the beginning of a worldwide technological shift. Betamax recorded an analog TV signal, but it did it on magnetic tape. Recordable media that could be erased and edited were becoming standard, partly because their contents could be (with difficulty) reproduced over long distances, even over the phone. Doing so was barely practical then, but it was the frail beginning of the wired world to come. Pictures and sounds were no longer held solely by their owners. Anyone with a few hundred dollars' worth of gear could grab a TV program, keep it, copy it, lend it. This is the first flicker of what we now know as file sharing. In fact, one of the first big legal fights over private copying of content involved home taping.

Almost nobody got it, except a few scruffy guys in Northern California. Vannevar Bush, in his essay "As We May Think," had envisioned nearly everything about the Internet except the ease of moving digital information around. The idea that photos, movies, music, and text were going to become data streams—that they might not even physically exist on paper or acetate—required a huge leap.

Land had the facts on his side, too. Consider this: A frame of medium-format Kodak film holds the equivalent of 80 million pixels of digital data. The same space on the screen of an Apple II computer—pretty good for 1977—held just 243 pixels, and it took a couple of minutes to boot the computer up to look at it. Why would anyone bother?

Ted Voss says he remembers hearing versions of that very argument (and its counterargument) inside Polaroid in the 1970s. Land himself, at the 1982 shareholders' meeting—his final one—rhapsodized about the efficiency and beauty of photographic film. It was "the first solid-state recorder," he said, and "It records the whole image at once, just as your eye and brain record the whole image at once. It records it in graduated detail. It records it with just a few photons of light. Twenty photons on a grain." Most people agreed. Ones and zeroes were for robots, not for people.

A lot of histories say "Land was fired after Polavision," and that is a gross oversimplification of what happened. He was too thoroughly enmeshed at Polaroid to be flat-out dumped, both because his family owned about 8 percent of the company's stock and because the board would never have done so. ("They were yes-men," is how one long-time executive put it.) But for the first time, people had something to throw back at him. He was no longer the man who'd always been right and always made everyone rich. Elkan Blout put it this way: "He liked winning, and when in the end he didn't win all the time, it became very difficult for him."

His competitive instincts did have one more outlet, however. Land had been called to defend his thirty years of innovation, and in doing so, potentially save the company he had built. The sleeping giant up in Rochester had awakened, and Polaroid was headed into court.

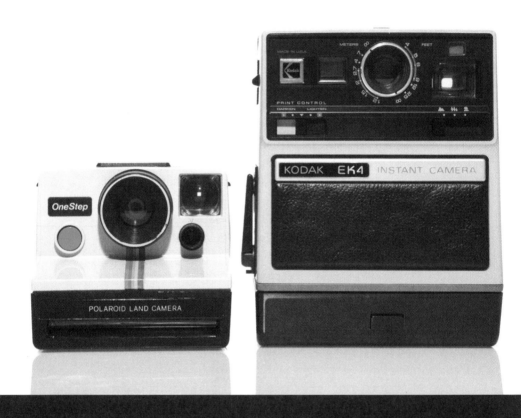

The lawsuit between Polaroid and
Kodak over their competing instant-
camera lines was the biggest patent
case of its time—and the settlement
is, to this day, the biggest one ever
paid out.

7 "Our Brilliance"

In the broadest sense, Polaroid always had competitors. Every photographer chose between instant and conventional film. The old decay problem, wherein buyers tired of their Polaroid cameras after a year or so, probably occurred because people drifted toward cheaper systems or into another hobby altogether. But even three decades into Polaroid's success, nobody else had seriously tried to compete on its turf. Up against a first-rate research operation with a tremendous lead, an upstart could hope, at best, to keep up. Besides, Polaroid's obsessive patenting habit wasn't just a matter of scorekeeping. It had locked up most of the field.

Still, other companies were tempted to try carving off a little slice of Polaroid's business, and in the early 1970s a company called Berkey Photo gave it a go. Ben Berkey had been in the photo business for forty years, running a New York–area chain of stores called Willoughby-Peerless and making cameras under the brand name Keystone. He had already made a bunch of money knocking off Kodak's inexpensive Instamatic point-and-shoot cameras.[1] Back in the 1940s, he'd declined to invest in Polaroid, and in 1973, *Time* reported that "Last year, Berkey finally managed to recoup a bit on that mistake: Keystone brought out the only instant camera that has ever been developed by a manufacturer other than Polaroid." It used pack film, and had an electronic flash, which Polaroid's Colorpack did not. It sold decently, and Polaroid did not take action against Berkey, because the SX-70 had come along and pack film was considered a backwater. A later Berkey camera, meant to use integral film, did provoke a lawsuit from Polaroid, and was pulled from the market.

Time was mistaken about one thing: There had been an earlier knockoff of a Polaroid camera, sponsored by an honest-to-god superpower. In 1952,

1 This immensely popular line was built around a quick-loading cartridge, but Instamatics were not instant cameras—they used ordinary film. Consumers confused the two words often, and even today, one occasionally hears reference to "a Polaroid Instamatic camera." No such thing.

GOMZ, the state-run camera-maker of the Soviet Union, introduced a product called the Moment. It was a nice clone of Polaroid's Model 95, down to the brown leatherette. It was also far too expensive for the Soviet citizenry, and the film was scarce, expensive, and awful. The Moment had passed into oblivion by 1954.[2] Another Soviet model, the KMZ Foton, was even less successful, with a plastic body that tended to crumble as it aged.

Really, though, neither Berkey nor Stalin had been a threat. The only competitor that mattered was Eastman Kodak. It held about 80 percent of the U.S. photo market, not to mention a not-so-secret weapon: its long-running agreement to make the negative portion of Polaroid film. The two corporations were ostensibly competing for market share, but from the beginning, it had been a fairly benign war, one that provided profits to both entities.

In April 1968, Polaroid revealed to Kodak the first faint details of what became SX-70, and the companies began discussing a contract that included the new product. When a new chief executive named Louis Eilers stepped in at Kodak, the talks went cold. Eilers believed that his factories shouldn't be supporting a quasi-competitor, and he took a new tack, saying that he'd supply negative for the new film only if Polaroid would let Kodak offer an instant-photography product of its own. Land wanted no part of that. He knew that, given Eastman Kodak's size, reach, and clout with dealers, the larger company would slowly crowd him out. The conversation ended, and soon after, Eastman Kodak declined to extend the deal to cover SX-70.

For Polaroid, making negatives was going to require a monumental investment, one that would have to be piled on top of its already huge spending on the new line. That was the reason for building the 340,000-square-foot factory in New Bedford: The principal force behind its construction was not Polaroid's growth but Kodak's ultimatum.

Behind the scenes at Kodak, the feeling was that instant photography was still growing, and this thing called SX-70—about which they knew the outlines but few details—was trouble. Kodak's best guess was that, over the years, Polaroid's SX-70 would cost it $6 billion in lost sales. Two instant-film research projects had already begun at Kodak. One was intended to create an integral film; the other, a peel-apart product that left

2 In 1965, GOMZ was renamed Lomo. More about that in chapter 9.

its rubbish inside the camera. The latter was well along its way in 1972, when the first SX-70 picture made its way to Eastman's research labs. It was a grim day in Rochester when it became clear just how far behind Polaroid the project was. The following October, when SX-70 first appeared in stores, Kodak's people immediately bought seventy cameras and thousands of packs of film, and whisked them off to be dissected. What they found confirmed their fears: Their peel-apart project was already outdated, two years before it was to appear in stores. The endeavor was abandoned. It had cost $94 million.

The integral film project kept going, but even Kodak, with its huge cash reserves, couldn't create that quickly. It was just as hard to invent a one-step system in Rochester as it had been in Cambridge—and Kodak faced the additional problem of working around Polaroid's patents. The project took seven years and 1,400 people, and the final result did seem somewhat different. Kodak instant photos were exposed through the

The Soviet Moment camera was pretty well made, but the film was a dog, and almost no Soviet citizen could afford it.

back of the film rather than the front, the image having been bounced off two mirrors rather than one. The cameras were not SLRs and would have ordinary viewfinders.

The Kodak EK4 and EK6 cameras and their film, called PR-10, were revealed in April 1976. This time it was Polaroid's turn to scoop up a bunch of cameras and cartridges and take them apart. The reaction in Cambridge was likewise dismayed, but for very different reasons. What Land's team saw was a photograph with a broad white frame, a pod at its lower edge, and a camera that ejected its film between rollers that spread a developer and opacifier. One TV reporter covering the introduction called it the new "Kodak Polaroid," and then had to correct himself. He was one of the first to be confused about the distinction, and definitely not the last.

The Kodak cameras were big and dumpy, with none of the coat-pocket sleekness that Land had demanded of his engineers. The cheaper model ejected photos with a hand crank rather than a motor. The pictures themselves compared well with Polaroid's, although they took a little longer to bloom and were more prone to fading. The cameras spit out their photos sluggishly—or as Land put it to his colleagues, "Theirs evacuates, while ours ejaculates." The chairman's public statement was more upbeat: Land told stockholders that he was proud that Kodak's best shot had barely matched his company's achievement. He sneered at the new camera's clunkiness, suggesting that one might best "confine its use to cocktail parties."

Six days later, the lawyers squared up: Polaroid sued Eastman Kodak for infringing on twelve of its patents. They covered hardware and film, structure and chemistry, and involved fine distinctions, like whether, for example, the acid layer of Kodak's film was positioned "in the photo-sensitive element" or outside it. Ten of those infringement claims made it to the trial, covering seven inventions.

In any patent-infringement case, the question eventually arises of intent. If the violation is deemed "willful" (that is, if the company at fault knew it was taking another's work, and went ahead anyhow), the plaintiff can receive triple its damage claim. So did Kodak just go ahead, planning to lawyer up later? Or did its executives believe that it had entered the field legitimately, with a distinctive system of its own?

Cecil Quillen Jr., who was Kodak's general counsel, says that Kodak was acutely aware of the landscape it was entering. Recognizing Polaroid's extensive arsenal of patents, its lawyers and scientists deliberately worked around them, going so far as to retain an outside legal firm, Kenyon & Kenyon, to monitor their work. "The belief at the time—late 1968, early 1969—was that Polaroid had a huge load of patents, and we were going to have to work our way through them in a way that didn't infringe," Quillen recalls. "And for that reason, we hired a top-flight outside lawyer to work directly with the research and development people. Their job was to understand what the research possibilities were, to identify the Polaroid patents that presented actual problems." Kodak's people also thought that Polaroid's relentless patenting of every small improvement might turn into a liability under the scrutiny of a judge. "There was a belief among some associated with the development that if Polaroid took a good hard look at their patents, they would not sue," says Quillen. Many of those patents were, in Kodak's view, the second or third re-patenting of inventions Polaroid had already disclosed. Those would not hold up under a judge's scrutiny.

Herbert Schwartz, who represented Polaroid (eventually becoming the top attorney on the case), recalls it a little differently. "Was it willful? I don't know…it's a funny word." He pauses. "In my view, it probably was. Judge Mazzone [who ruled on the damages case] never found it willful." At the time, *Time* magazine reported that Kodak's lawyers had, early on, spent "six or seven years" poring over Polaroid's patents, then advised Kodak to go ahead even though it might be sued. That may not be willful, but it's at least very, very aggressive. One of Polaroid's positions during the trial was that Kodak had cherry-picked the material it sent to Kenyon & Kenyon, in order to get back the advice it wanted.

Schwartz also offers another hypothesis. "You know—and I just have heard this anecdotally—they said that, when Land was a young man, he didn't litigate a patent case because he didn't want to testify in court." (This tale probably refers to one of the early polarizer lawsuits.) Kodak may have heard the same story, and it does sound believable. Land was not the sort to relish being cross-examined, and it is just plausible that Kodak said "he'll never sue us," and plunged ahead.

If that was so, Kodak got him all wrong. Land may have been deadpan with his employees, and chipper with the stockholders, but he was furious. To him, Kodak's system was a shoddy, inelegant pretender, yet Kodak still had the chance—for peripheral reasons, involving things like better distribution—to overpower his carefully built edifice of reason and labor. "Kodak terribly miscalculated his personality," Schwartz says. "One of the reasons he put his heart and soul into [the lawsuit] was that he was outraged." Land said as much, a few days after the suit was filed, at a shareholders' meeting: "We took nothing from anybody. We gave a great deal to the world. The only thing keeping us alive is our brilliance. The only thing that keeps our brilliance alive is our patents." Or, as Sheldon Buckler recalls, "In his view, it was ours, and now they wanted to take it away from us."

JULY 1976 75 CENTS

Popular Science
The **What's New** magazine ®

The new solar architecture
Houses that capture more energy from the sun

Life on Mars?
The search begins
By Wernher von Braun

The new
CB radios
you can buy now

- How it works
- How it compares with Polaroid

Kodak's new instant-picture camera

KODAK EK6 INSTANT CAMERA

PRINT CONTROL
DARKEN LIGHTEN

Popular Science gave each product introduction its own cover story. In head-to-head ratings, it expressed preference for Polaroid's sleeker cameras and Kodak's color.

The suit's discovery period took years, and the trial began in October 1981. In the interim, the two companies duked it out in department and photo stores. Kodak's film improved; so did Polaroid's. Kodak expanded its line of cameras. Polaroid's OneStep appeared, as did its fast-developing, brighter-hued Time-Zero film.[3] In these years, the whole field of instant photography expanded, and a licensing settlement seemed like the way the trial would end. Kodak (went the thinking) would pay Polaroid a big annual fee for use of its patents, and the two would compete for market share, boosting the whole field.

The showdown moment occurred with Edwin Land on the witness stand. He was in rare form, both charming and cantankerous: correcting Kodak's lawyers, outfoxing their arguments, making perfect analogies. Most of all, he challenged the attempts to pick apart the integrated system that was SX-70. Land had always talked about it in holistic terms, where each individual system interlocked with every other: optics, mechanisms, chemistry, film manufacturing, everything down to the little space (called the trap) at the top of every instant photo, sized just right to catch the overflow drops of processing goo. The nature of patenting, however, and especially a patent trial, is to look at each piece discretely. Why is the trap unique? Is it like other fluid traps? Is it obvious to anyone that a trap of that size could do the job? If that last point is true, it's not an enforceable patent. This approach appeared to drive Land nuts, and the judge, Rya Zobel, occasionally had to reprimand him for his prickliness on the stand. He was impressive enough, says Schwartz, that he and his firm broke a longstanding custom. "One of the classic rules of trial lawyering is that you don't do a demonstration in the courtroom," he says, "because if it doesn't work you're done for." Needless to say, this was no ordinary demonstrator, and Schwartz let him show off his stuff for the judge, slicing the edges off a curled-up test photo to prove that it would immediately flatten out, contradicting a Kodak claim. (It did.)

When Zobel finally handed down her decision in 1986, it arrived with a wallop. Seven of Polaroid's patents were upheld, with damages to be figured in a later trial. Most eye-opening, however, was one line in the judgment. Kodak was "enjoined and restrained from … without limitation, by manufacture, use or sale of PR-10 film and EK4 and EK6 cameras."

3 Land was especially proud of Time-Zero because he'd brought it into being during the distractions of his deposition. "We can't stop creative people," he crowed at a shareholders' meeting. "I don't know what Rogers invented during his."

Polaroid's lawyers had thought it unlikely that they'd get Kodak's work stopped by the courts. Schwartz was an exception, and Land vigorously backed him. Sheldon Buckler remembers that Land had read the statutes himself and all but demanded it, saying "the law says I'm entitled to an injunction."

Even more surprising, he got it. Judge Zobel was not just saying "go back to your corners and work out a deal"; she was pulling Kodak out of the entire field. Sixteen million Kodak instant cameras had been sold, and there would be no more film for them. The ruling gave the company no time to redesign or try to come up with a workaround. It was the first time such a big business had been shut down by a judge.

Quillen has always felt, he says, that Kodak was done in by a new approach to patent law. In 1982, Congress merged two courts to form the United States Federal Court of Appeals for the Federal Circuit. The new appeals court was more pro-patent than its predecessors, and lower judges, not wanting their decisions overturned, began to adjust their rulings. Kodak's lawyers note that a judgment from 1981, in which Zobel dismissed one of Polaroid's patents, contrasts with her final ruling in 1985. "It is my belief," says Quillen today, "that at least six or the seven patents that were ruled valid and infringed would have been ruled invalid if the 1981 law had been applied." Unsurprisingly, Schwartz disagrees.

Kodak now faced a class-action suit from all its angry customers, and ended up paying out a settlement to everyone who pried the nameplate off the front of his or her camera and mailed it in. Owners got about $60 each, or a new (non-instant) camera. Even today, Kodak has a posting on its website explaining that the offer has expired.

One unexpected beneficiary of this fight was Fujifilm of Japan. Fuji also had its eye on instant photography, and played the good cop to Kodak's bad cop, making an offer to Polaroid: You give us a piece of the Japanese instant-photography market, and we will give you expertise in new fields you wish to enter, like magnetic tape. That was a deal Polaroid could live with, and soon, Fuji was making its own integral film and Polaroid-compatible pack film.

Onward went the lawyers, to figure the damages. If the judge were simply to set an appropriate royalty payment for Kodak, it would be

about $100 million. If lost profits were figured in, it would be much more. Numerous other questions arose. Sales of instant cameras had dramatically risen between 1976 and 1979; for how much of that was Kodak responsible? If Kodak had never entered the market, would the instant-photography world be smaller overall? During the sales decline in the early 1980s, did Polaroid lose sales to Kodak's product, or to 35-millimeter film? What about the competitive price-cutting that had gone on, possibly depriving Polaroid of some income? Finally, there was the question of willfulness. Polaroid said it had lost $4 billion, which at triple damages was $12 billion.

The trial lasted into late 1990, bringing the time spent on the case to fourteen-and-a-half years. Judge Zobel had, by then, recused herself, and Judge A. David Mazzone had taken over.[4] Polaroid's final position was that it had accelerated production of its cheap cameras and sold them at minimal profit to counter the Kodak threat, and that it could have otherwise focused on cranking up its film factories and selling millions of extra packs. In its counterargument, Kodak argued that what Polaroid might have been able to do was irrelevant; what mattered was what it had actually been capable of doing. There were also significant arguments about whether price competition had really cut into Polaroid's margins.

Judge Mazzone's calculation of lost profits, business growth, demand curves, and every other aspect of the business is an impressive piece of work. No detail was too small to enter into his figuring. For example, Kodak had opened up an instant-photography market in pre-revolutionary Iran. Observant Muslims were not allowed to photograph women in public, and they wanted cameras with electronic flashes that could be used indoors. Since some of Kodak's cameras had flashes and most of Polaroid's didn't, those sales could not be considered lost to Polaroid.

On October 12, 1990, Mazzone issued his ruling. Polaroid was to get $909,457,567.[5] It was the biggest patent-infringement judgment ever, and although there have been larger awards since, those have been overturned on appeal. Nobody has ever paid out more at a judge's behest over a patent. Land must have been pleased, though he did not publicly comment on the result. (By that time, he'd severed all his connections with Polaroid, even the ceremonial ones, and he was in poor health.) Yet it was a bittersweet moment. The award was hardly $12 billion, or the $5.72 billion that

4 For the oddest of reasons: Zobel's mother-in-law had died, leaving her a sizable block of Kodak stock.

5 Later reduced to $873 million. After final negotiations and threats of appeal, the companies settled on a round $925 million.

Polaroid had formally requested, or even the $1.5 billion that Wall Street analysts had built their estimates around. It could arguably be called a weak victory for Kodak, because they could afford to pay the bill and be done with it. After the news came through, Kodak's stock price perked up. Polaroid's dropped more than 20 percent.

More than that, though, the photographic landscape of 1990 was very different from that of 1976, when the case had begun. Eastman Kodak had dived into the instant-picture fray on the theory that it was going to be a huge business. By 1982, it was showing signs of contraction, and Land was testily defending his field: "There's a lot of nonsense in the newspapers saying 'instant photography is on its way out.' That's like saying 'the instant kiss is on its way out. Hereafter you'll get it by mail order.'" But by the end of that decade, the industry had stagnated. Polaroid's growth had flattened, especially in the United States, and Land's successors were casting about for the next great idea, which was not forthcoming. After the lawsuit was resolved, B. Alex Henderson, an analyst at Prudential-Bache Securities who tracked Polaroid, told the *New York Times*, "It's hard to figure out what they can do to really turn around earnings in the long run." Polaroid was heading toward a situation that even a billion dollars, dropped in from the sky, could not fix.

David Levinthal's *American Beauties* series of 1989 and 1990, shot on the 20x24 camera, suggests both innocence and foreboding, play and something sinister.

8 Going Dark

Ask Polaroid people where things started to go wrong—was it at some point in the 1980s? earlier? later?—and everyone has a different answer. One blames inflexible engineers, another financial missteps. Some even point at the Kodak lawsuit, which required brilliant people to pick over their past when they could've been imagining the future. What's clear, though, is that the decline began almost imperceptibly. In 1978, Polaroid had more than 20,000 employees. Within a couple of years, small reductions in the labor force had begun. By 1991, after substantial cuts, it had stabilized at about 5,000, and the billion-dollar Kodak settlement had plopped into its bank accounts. A decade later, even having received that immense windfall, Polaroid was bankrupt.

Digital cameras are an obvious reason, but they're only the last little slice of the story. By the time the digital business started to carve away at film sales in the late 1990s, the alarms had been sounding for years. Even as Polaroid's fine-arts reputation and its pop-culture presence bloomed throughout the 1970s and '80s, Wall Street was growing increasingly bearish on the company.

It's tough to name any one villain, somebody who canceled a promising project or championed a big money-loser. The big talking point is always the same, though: Was the problem simply that Polaroid did not work without Edwin Land?

At some companies, the loss of a visionary leader causes an obvious and immediate decline. RCA, for instance, was flourishing in 1970 when its founder, David Sarnoff, handed full leadership over to his son Robert. The heir leaped into a diversification program, getting into every business from frozen foods to car rentals. Within five years, RCA was on the ropes,

SelectaVision was a disaster, Sarnoff the elder was dead, and Sarnoff the younger was dumped. A decade later, the faded company was bought and absorbed by General Electric, and RCA ceased to exist.

On the other hand, there are plenty of cases where the founder waits too long to get offstage. In 1943, Henry Ford bounded out of semi-retirement to reinstall himself as president of the Ford Motor Company. The 79-year-old was paranoid and growing senile, and was certainly not up to running a giant corporation. Ford Motor just barely survived his two-year return engagement.

What happened at Polaroid was different. The labs didn't suddenly go stupid the day Land left; the executive suite was not restocked with bean-counters who starved the great innovation machine. There was no incompetent, no charlatan. The air went out of the balloon slowly, over two decades, and as it sagged to the ground, nobody could find a way to get it aloft again.

In fact, there are plenty of Polaroidians who say the problems began with Land himself. For all his vision, he didn't care about naming a successor (as business schools say a CEO must). Ken Olsen, the chairman of Digital Equipment Corporation and a longtime Polaroid board member, said that Land "was teaching him how not to do succession." Once, when a reporter asked Land to describe what sort of person his successor would need to be, the founder reeled off an unachievable list of qualities, then started laughing, and said, "We're making him down in the lab."

Other executives had hoped to inherit Land's chair, and eventually gave up and left. Stan Calderwood had quit in 1971. Another candidate, a superb chemist named Stanley Bloom—the man who, with Land, had figured out SX-70's opacifier—died suddenly at just 47, while on a Polaroid business trip.[1] Tom Wyman, Polaroid's general manager, bolted in 1975.

When Wyman gave his notice, Polaroid's stock had not recovered from the pounding that it had taken after the SX-70 introduction. His departure shook up Wall Street's analysts even further, and Bill McCune was able to use that as leverage, demanding the company's presidency from Land. Both men knew that a second high-profile departure would give the impression of a company that was in chaos. Land agitatedly went

1 An observant Jew, Bloom had on principle never set foot in Germany, but in 1978 grudgingly agreed to make one trip to the Photokina trade show in Cologne, spending a single night aboard a boat docked on the Rhine. He died in his sleep.

McCune and Land at Land's retirement dinner. The body language says it all: McCune looks reflective; Land, a little grim.

to Julius Silver, asking what to do, and Silver advised him to give McCune what he wanted. Land finally agreed.

It was, almost surely, the right call. Land hadn't quite made William McCune in a test tube, but they'd spent thirty-six years battling and collaborating. McCune had imbibed a lot of Polaroid corporate philosophy from his boss, and besides, he had a lot of support. "He was the brightest of all of us," says Buckler, "and he was a naturally likable guy. When he had to do something not-so-nice, he did it in the nicest possible way." He had a fine technical mind, and the refined eye for beauty that many engineers lack. Those qualities outweighed his flaws—that he absolutely hated shopping, for example, which might be considered a handicap at a company that depended on retail sales.

McCune had a strange relationship with Land after taking over. Although Land was still chairman and director of research, he had to get approval for his projects, sort of, and the resultant friction was probably unsustainable. The final break came within a few years. Since the

beginning of SX-70, Land had wanted a small camera, a sort of extra-petite version that would be barely larger than a pack of cigarettes. In-house, it was called the Clamshell, because it popped open to expose the picture, then closed up again. Around early 1980, he began trying to revive it, digging up his old idea of a scanning camera and reconvening a group to work out the design. As the team figured out what to do, it became Land's role to get the project budgeted. He approached McCune, who didn't want to do it; Land countered, saying *Either you fund this, or I quit.* McCune said no, and that, implausibly, was that. Though he retained a lab for a couple of years, that arrangement would end soon enough. After forty-five years, Edwin Land was leaving Polaroid.

There was certainly sorrow and anxiety at Polaroid when Land retired, but a few senior employees also sensed, around the edges, that it was time. *Fortune* magazine had written a few years earlier that "there is no No. 2 man in Cambridge, only a group of No. 3s," and a lot of the threes had long felt under-recognized. Working in such a long shadow was hard on ambitious and talented people. According to Sheldon Buckler, their discontent had been steeping for decades. When he started in 1964, he says, "the founding fathers took me aside—invited me for lunch or coffee—and explained to me that they were the ones that were really behind the success of the company.... They thought they had all been in this together, forming the company and its initial success. There was something about these people all seeing themselves in an unrealistic way, in terms of how much they had contributed." They had all been specialists, satellites orbiting Land's sun—but each of them had been the sun within his own department, and had come to believe in his own heliocentrism.

"Land didn't want full-blown, fully realized people," Buckler continues." He wanted an expert in this or that to interact with him, and it would all come together through Edwin Land.... Land was so needy, in addition to everything he earned himself, he also took what was theirs. And they sort of resented it.... They all felt, he didn't recognize what he did. They were always in his shadow. But they stayed. And they loved it. And it was seductive. And I was seduced too, to a degree. And you know, there wasn't anything else—I'd worked for a couple of other companies before, and they weren't remotely like Polaroid."

In April 1980, the handover became fully vested. McCune became chairman as well as president. Land retained the director-of-research title for two more years. At the annual meeting, he received a retirement gift that he adored: two bull-mastiff puppies. The shops built him his very own 20x24 camera, too.

Gradually, through the early 1980s, the founder cut all his ties, left the Osborn Street lab, and sold all his stock. He didn't say it out loud, exactly, but the sentiment was pretty clear: *If I can't play this game my way, I'm not sticking around.*

In retirement, he kept doing what he loved, only without the distractions of executivehood. To feed his admitted addiction—"an experiment a day"—Land financed the creation of a research institution called the Rowland Institute of Science. Named for the great Johns Hopkins University physicist Henry Rowland (mentor to R. W. Wood, whose textbook had started Land on his way), it had its own campus on the Charles River, not far from Harvard and MIT. Land sold off his Polaroid stock to build its endowment. "The Rowland" kept him busy and content, even as age-related health problems began to encroach upon him.[2] Old friends, like Marie Cosindas, would drop by to visit; young acolytes, like Steve Jobs, made pilgrimages to meet him there.

At the Rowland, he and the Institute's other fellows, including some former Polaroid colleagues, could study whatever basic science they pleased. Land's research on the way the brain and eye perceive color culminated in a theory he called "Retinex." It had first been published in 1959, and became the work for which he wished most to be remembered. "Photography...that is something I do for a living," he once told the *New Yorker*'s science writer Jeremy Bernstein. "My real interest is in color vision." Retinex is difficult to explain in a couple of sentences, but a quick summation goes like this: Conventional wisdom has it that humans perceive colors because objects reflect only certain wavelengths of light to the eye. As it turns out, Land—through some strikingly simple demonstrations, involving black-and-white slides and monochrome filters—could make those colors appear without the wavelengths that ought to be producing them. Land was able to show that if a very narrow range of color (sometimes just a small portion of

2 In 2004, the Rowland Institute merged with Harvard University, where it operates as a semi-independent bubble within the school.

the yellow band of the spectrum) is present, the eye and brain do most of the filling-in.

Polaroid without its founder did not immediately disintegrate, the way RCA had. During McCune's presidency, both before and after Land's departure, it was probably more stable than it had been in the early SX-70 years. It was, however, becoming a different company, a much more conventional one. For example, the classical approach to the film-decay problem—whereby a new Polaroid user shot a couple of packs, then put the camera in a closet for good—had been to keep finding new camera buyers, and McCune's way of doing that was to bring the camera's price down, a lot. Land had been uneasy about that, sensing that a lot of cheap cameras would devalue Polaroid photography, but McCune powered ahead.

The result was the Pronto!, the chunky plastic camera that today represents "Polaroid" in the minds of most people. It was nearly all plastic, designed to be snapped together by workers with minimal training. The entire camera contained just one screw, in the shutter mechanism. The Pronto! was inexpensive to make and to buy, and its even cheaper successors, some of which barely cost more than a pack of film, were marketed under names as varied as the Button, the Spirit, the 1000, the Sun Camera, and (especially) the OneStep. First using SX-70 film, then its successor Time-Zero, and ultimately the 600-speed film that would supersede both, the Pronto! and its descendants almost surely constitute the single most ubiquitous camera ever made. At the peak, five to six million went out the door every year. The design received a cosmetic update often to stimulate camera purchases and perk up film sales. Because of its purity and simplicity, the OneStep also took significant market share back from Kodak's inexpensive cameras.

Its advertisements were a sensation. First, Alan Alda, at the height of his popularity on *M*A*S*H*, signed on. He was soon succeeded by James Garner, who was joined by a relatively unknown actress named Mariette Hartley. The couple's easy, witty onscreen banter, bits of which were improvised on the set, was electric—so much so that viewers widely assumed that the two were a real-life couple, maybe the sort who took private Polaroid pictures of their own.[3]

3 Those short dialogues for Hartley, by Phyllis Robinson's successor Jack Dillon, changed the way advertising copy was written for women: Hartley was Garner's complete equal in these scenarios, and often came out on top in their little fencing matches.

Although the Pronto! and OneStep sold literally tons of film and cameras, they incurred another kind of cost. These cameras were not outsourced; rather, they were made by Polaroid itself, both in Norwood, Massachusetts, and in another plant overseas in Scotland. At the same time, the New Bedford factory was making negative by the truckload, and film packs were pouring out of the big complex in Waltham, west of Boston. Polaroid had brought its battery-making in-house, built another Scotland plant to make sunglasses, and constructed still another factory in the Netherlands to supply Europe with film. In short, a company that had been a product-minded think tank, contracting out much of its production, had, bit by bit, become a manufacturing business. That brought a lot of relatively conventional corporate headaches: infrastructure investments, the odd labor conflict, and, most of all, high fixed costs. Those production lines were scaled for high volume, and their staff had to be paid in good times and bad. If business were to slow down, the factories would become expensive deadweight.

Which is exactly what began to happen. In just four years, from 1978 to 1982, Polaroid's share of the overall U.S. photo market fell from 27.1 percent to 17.4 percent. Though some of the loss was owed to Kodak's insurgent instant-camera business, the larger problem was conventional 35-millimeter picture-taking. A few years earlier, Eastman Kodak had reformulated its color film so it could be processed faster. The result—the one-hour photo lab—recast the entire business of amateur photography. When your options were an instant Polaroid picture or a week's wait by the mailbox, the choice was usually clear. But the difference between sixty seconds and sixty minutes was much less dramatic, especially if you could drop off your film at a Fotomat, swing by the supermarket next door, then pick up your pictures before you went home. It wasn't instant, but it was fast enough for a lot of people.

It also arguably looked better, and this is a sore subject for a lot of diehards. Polaroid peel-apart film has superb resolution, and if you attach a Polaroid back to a serious camera, you can (with practice) produce images as technically fine as the ones Ansel Adams made. Integral film, though not as sharp as pack film, looked pretty great in the hands of a skilled photographer with an SX-70 camera. Most amateur snapshot-shooters

were using a OneStep, however, and with its limited focusing range and plastic lens, it often produced murky, mediocre pictures. Inexpensive 35-millimeter cameras kept improving, too, as Japanese manufacturers like Olympus and Canon made them smaller and sleeker. They'd fit in a small pocket when you went on vacation, which the boxy OneStep emphatically did not.

Despite hundreds of millions of dollars spent on film quality, Polaroid photography began to gain a junky reputation, exactly as Land had feared. The dominance of OneStep cameras began to give the impression that Polaroid film was something kids might play with and insurance agents might use to document dented cars, but nothing you'd use to shoot anything important. A few thousand beautiful pictures by Adams, Kertész, and Evans could not overshadow the one billion iffy snapshots made every year. With the failure of Polavision and the enormous expansion behind SX-70, Polaroid had effectively become a one-product company. If that one product was perceived as mediocre, and the competition was getting better, the future would not be bright.

McCune, to his credit, understood that. Since taking over the presidency in 1975, he'd been pushing to broaden the company's business without going down the dangerous road of full-on diversification. Polaroid started importing technology from partners like Fujifilm, and using its expertise in certain manufacturing fields (like laying down thin coatings) to start new product lines. Products soon appeared on the market that seemed high-tech: Polaroid disk drives, floppy disks, videotapes, and even (a few years later) a line of conventional film.

They made some money. But none was a game-changing success, and their profusion masked a basic problem: Not one of them was a fresh invention. The world already *had* floppy disks and videotapes. The Landian motto "Don't do anything that someone else can do" had made life difficult at times for his employees, but the alternative was to offer mildly differentiated versions of things people want and use already. Technology companies start falling behind even before they introduce a new product, so the next one must leapfrog its predecessors and supersede its competitors. Those companies have to be unafraid of cannibalizing a

THIS PAGE and OVERLEAF:
The filmmaker Gus Van Sant
started using a Polaroid camera
in the late 1970s, as many directors
do when casting. But his exacting
eye (not to mention his rising level
of celebrity access) turned those
portraits into something more. At left,
Tony Gillan and Patricia Arquette;
on the following page, Nicole Kidman
and Lucian Caprar.

market they themselves have created—to be stealing buyers from their old product lines with the next ones.

Some people are tough on McCune, saying that he managed reactively, waiting for people to bring him ideas rather than creating a big strategy. But the record shows that he planted a lot of seedlings that could've grown up into big things. McCune built a lab devoted to microelectronics—with its own dedicated and very expensive building, complete with clean room—and began to dig into the nascent field of digital imaging. It was a rather bold move at a time when it took a disk drive the size of a file cabinet to store a single photo's worth of data. It was also mostly new territory for Polaroid, although the company's electronics expertise had been honed on the SX-70 camera project, and, as McCune told the researchers Mary Tripsas and Giovanni Gavetti some years later, "If you have good technical people, you shouldn't be afraid of going into whole new technical areas." References to what was being called the "filmless camera" or "electronic camera" began to appear in Polaroid's press throughout these years. By the mid-1980s, Polaroid, in a joint venture with Philips, was on the verge of making a digital sensor that produced a 1.2-megapixel image, and had the data-compression algorithms to go with it. By 1987, talk was afoot of taking it into production. The company's marketing talk subtly shifted during these years, too: "the leader in instant photography" became "the leader in instant imaging."

It's heartbreaking to see this from two decades' distance, because Polaroid had once again created something that would have astounded consumers. Unfortunately, it would also render everything else the company made obsolete, and that spooked people. "Polaroid could make the digital transition," says Sheldon Buckler, recounting the prevailing attitude. "But...there's no money there, because there's no film. And there'd be no competitive advantage on the hardware side in the consumer arena, because there's Nikon and Sony and Canon and a host of others."

It's clear now (and was anything but obvious, back then) what the best call would've been. If Polaroid had played its hand a little differently, the computer on your desk wouldn't be attached to a Hewlett-Packard inkjet printer; you'd have a nifty little PolaJet, printing photos on high-quality, high-profit-margin Polaroid paper. The margin on PolaJet refill cartridges

would be similarly wide, and you'd buy them for years—that is, until Polaroid rolled out the next-generation printer, whereupon you'd run out and upgrade because it was just so cool. It'd probably be wireless, too.

Polaroid during these years not only grasped this—it was actively pursuing it. Engineers were hard at work on non-impact-printing technologies like inkjet and thermal transfer. Eventually Polaroid bought a local company called Advanced Color Technologies, which was developing large-format inkjet printers, and had a pile of patents on inkjet-printing heads.

Why didn't Polaroid become a printer company? That old bugbear known as "photographic quality." A technology didn't just have to work; it had to be beautiful. At the time, inkjet printers produced coarse, muddy images, and few people at Polaroid believed that photographers would ever be happy with anything out of those machines. As one employee put it, "The engineering department refused to accept the bad taste of the consumer."

It was a big misstep. After all, the OneStep's photos weren't great either. Nor are the pictures we see every day in newspapers. Our eyes forgive a lot. Engineer Mike Viola recalls that although the inkjet project was coming along, "upper management decided that the quality would never be photographic. So they disbanded [Advanced Color Technologies], and its people went on to found the largest and most successful wide-format inkjet-printer company in the world."

By then, the upper management in question was shifting again. In 1985, Bill McCune turned 70 and retired from the presidency. Though he retained his position as chairman of the board, McCune handed off the day-to-day job to Israel MacAllister Booth. "Mac," as he was almost universally called, was an engineer specializing in production, and had been rising through the company since 1958. He'd built the New Bedford factory in time to keep Kodak at bay, and as Polaroid had begun its shift from idea lab to consumer-products company, he had been absolutely invaluable. McCune had perceived a few possible successors within the company—Peter Wensberg from marketing, Dick Young from international, Sheldon Buckler from research, and Booth from manufacturing. "Each one represented a different philosophy toward running the

business," recalls their colleague Sam Yanes, "and he was comfortable with another engineering type. He felt that Booth was the most financially responsible. A lot of people think that was a big mistake."

Talk to a lot of old Polaroid employees about Mac Booth, and you get a divided response. Many are fond of him, not least because he was a true believer in Polaroid's ideals. Land and McCune's forward-thinking ways of treating employees—great benefits, an aversion to layoffs, education grants, community outreach—were harder to justify when times were lean, and Booth stayed committed to them. He kept R&D spending high, at a time when a lot of executives would have slashed the lab budgets. He was also known as a good listener, willing to hear out unorthodox ideas.

The fact remains, though, that he did not have a grand overarching idea for Polaroid's future. He was a highly skilled production guy: *Let's do what we do, get the costs down, and improve it relentlessly.* Some of his old colleagues also grumble that, although Booth was a very intelligent man, he put a few executives in place—longtime associates from the factory operations, people he had become comfortable with—who were not as smart and creative as the company needed them to be.

For 1986, Polaroid's big splash was a new line of cameras and film, called "Spectra" in the U.S. and "Image" overseas. The cameras folded down, somewhat like the original SX-70 had, and had good lenses. Most obviously, they used integral film that was about half an inch wider than the SX-70 format. Spectra sold well, especially in professional markets like police departments and dental practices. It even had the effect of reviving sales of film for older cameras, because people were paying attention to instant photography again. The Japanese-American artist Patrick Nagatani, for one, made some unbelievably intense pictures on Spectra film.

Underlying Spectra, though, was no seriously new technology. The dyes in the film had gotten a little better, yes, but otherwise this line was a product of market research. Lacking a big vision, Booth had gone to the public to see what people wanted, and they'd requested larger rectangular pictures, presumably like the ones they were getting from 35-millimeter cameras. Whereas Land's Polaroid was built on his belief that "every significant invention…must come to a world that is not prepared for it," Booth's asked the world what it wanted, then made it.

NAGATANI 1986

Armed with the new Spectra camera and a case of what he says was "the best Spectra film ever made," Patrick Nagatani made tableaux of cinematic dread, like this one, titled *d'Alamogordo Blues*.

The world didn't know to ask for a digital camera yet, and because that product had its share of detractors inside Polaroid, the project kept hitting roadblocks. Digital products would be proposed, then refined, then scratched ("Where's the film? How do we make any money without film?"). Nonetheless, in 1987, Booth told *Fortune* magazine, correctly, what was coming: "'I think it will be five to ten years until an electronic camera hits the mass market, but we're going at it like it might happen tomorrow." According to a confidential July 1987 memo outlining plans for "electronic still cameras," production was to begin the next year, with the possibility that the first model would be made in small numbers but not sold.

It, too, got stuck: The techies didn't think the photos looked good enough, and the businesspeople couldn't see how to turn a profit. Jerry Sudbey, then vice-president of manufacturing, put it this way: "Electronic imaging is a technology, not a business. Polaroid is not trying to be in the consumer electronics business."

At any other time in the twentieth century, a few stop-start years would likely have been just a misstep in a company of this scale. As it turned out, though, photography was beginning a convulsive metamorphosis—the biggest one it had seen since Eastman's "You push the button, we do the rest." Everyone saw it coming, but the magnitude and speed of the shift was striking. In 1995, only a few gearheads had seen a digital camera. By 2005, film was widely considered a goner. Those few indecisive years were far more critical than they may have seemed at the time, as Polaroid ceded an enormous amount of future ground to its competitors. (As did Kodak.) Polaroid was even going backward: The company closed down its microelectronics lab in 1993, selling it off to MIT.

People still ask whether Land would have known what to do. He was very old by this time, and world-changing leaps—like the one from analog to digital—have, historically, been made by the young. We do know that he was besotted with the beauty of analog picture-taking. But he also was capable of openness when it came to big ideas. He once remarked to John McCann that there were lots of ways to make an instant photo—that they'd just settled on the one they'd figured out. If Land had been thinking about recording audio captions on his photos thirty years earlier, was a

picture made of ones and zeroes so outrageous? He might have looked at a prototype digital camera attached to an inkjet printer, around 1985 or so, and said, "You know, if we compress the data a little better, we could send pictures over the phone," and founded America Online. Or maybe he'd have been horrified at the bad color and rough pixellation and tossed the idea overboard. It's a good guess, though, that he wouldn't have been the enemy of a good young person with ideas.

In any case, it was academic. He had distanced himself from all but a few people at Polaroid, even skipping the fiftieth-anniversary party in 1987, sending only a brief letter that Booth read from the lectern. (That year, he told *The Economist* that he'd pulled away on purpose, so his successors could "learn to be proud of what they were doing.") He did not get to see the digital revolution come into flower: On March 1, 1991, after a couple of years' failing health, Land died at the age of 81.[4] The World Wide Web was nine weeks old.

To be fair to Mac Booth, he spent a lot of his presidency in a more immediate battle than the distant threat of obsolescence: He had to fight off Roy E. Disney. Yes, *that* Roy Disney, Walt's nephew: the man who, as a child, had been the test audience for *Pinocchio*. His family's private equity group, Shamrock Holdings, saw in Polaroid a company that was largely debt-free and had a core business that was still bringing in a lot of cash, but seemed a bit sleepy and probably had a big windfall from Kodak on the way. A man named Stanley Gold ran Shamrock for the Disney family, and in 1988, he made an offer to buy up Polaroid stock.

Polaroid resisted, hard. "They hated me!" Gold says today, recalling the battle. "This was clearly an underperforming company. There's a cycle in companies that is pretty obvious—[at the start] they're dynamic, energetic, making headway. That was clear when Land was there. Those people are usually succeeded by bureaucrats, and what a company needs then is a re-energized management team. I thought that it had a real opportunity: It was the beginning of digital photography, and they had a name that meant 'instant.' And they weren't taking any advantage with it!" Gold suggested brash marketing tactics, too: a kiosk at the entrance to every big amusement park (including Disney's, naturally) where a visitor could buy packs of film and borrow a camera for the day.

4 At his family's request, all his papers were shredded after his death. Land and Polaroid disliked being written about, except when it suited their commercial or intellectual purposes. Land insisted that he wanted his legacy to be his published scientific work rather than a cult of personality, which may explain why he is, today, somewhat less of a household name than, say, Edison, Bell, or Jobs.

To introduce the Spectra system in 1986, Polaroid erected this outsize booth in front of the World Trade Center.

Over the next nine months, Shamrock's per-share offer crept upward—first $40, eventually as high as $47, for a stock that had been trading around $31—and Booth spent a lot of time running back and forth to Delaware (where Polaroid, like many American corporations, was formally incorporated, and where the lawyers were working). Sam Yanes remembers that Booth was "at his most touching...I was hauling his Maalox for him, as we went around Delaware." Back home, sentiment was with Booth—the *Boston Globe* started referring to "The Dreaded Stanley Gold," even though his ultimate offer would've put the company's value very high, at $3 billion.

In the end, Polaroid outplayed Shamrock, with a move that the *New York Times* called "a potential classic." Before the takeover attempt, Polaroid had been establishing an employee-stock-ownership plan, or ESOP. "Booth believed in the ownership culture," recalls Yanes. "He felt that if employees had a stake in the company, they'd work more efficiently." Faced with the takeover, Booth expanded that plan greatly, selling it nearly 15 percent of the company's stock. Additional shares were

sold to an investment group under a guarantee of profits, in return for two loyal board seats. Under Delaware law, a buyer has to get 85 percent of a company's shares to purchase a firm without board approval. Neither those guaranteed investors nor Polaroid's employees were going to vote for an outsider who could come in and stomp all over their turf, and in March 1989, Gold quit the takeover attempt. ("I made some money on the deal," he says.) The day Gold bowed out, Polaroid's employees flooded from their headquarters for an impromptu rally in Technology Square. Someone made up T-shirts: POLAROID FAMILY SAID "NO" TO STANLEY.

It was a triumph...and an expensive one. To issue all that stock, Polaroid had to take on about $300 million in debt. To pay off the loans, the company needed to keep its cash flow up, and to do that, it needed to keep the film factories humming. Polaroid's two big projects of the early 1990s—exactly when it should have been looking beyond analog photography—were devoted to just that.

One was yet another line of integral-film cameras. Code-named Joshua, it was intended, even more than Spectra, to meet the 35-millimeter challenge. Joshua would be foldable, and its photos would eject into a small compartment on the back, allowing you to shoot multiple frames fast, on the fly. This, too, was a pure product of market research: It looked like a conventional camera when it was closed up, presumably because that was what people said they liked.

It made it to market in 1992, under the name Captiva, and by then, it was a heavily compromised design. It had grown, as the Polaroid aficionado William Sommerwerck nicely phrased it in a review, "startlingly bulky." Two decades after the first folding SX-70, all Polaroid had to offer was a bigger camera that made smaller photos. Customers responded by leaving the Captiva on shelves. It lingered on the market for a few years, but it was no game-changer. Somehow, an item that did everything people said they wanted had little to do with what they actually wanted.

The other product line was called Helios. It was a dry-film system that worked a little like a photocopier, and it was meant to produce quick prints of X-rays in hospitals. Polaroid threw a huge amount of money behind its development, about $120 million per year. Like Captiva, it was slow out of the gate, arriving in 1993, and it too failed to catch fire, for a variety of

Jamie Livingston's simple project—a single Polaroid picture every day, with no retakes, even if a better one presented itself—ran for more than 6,000 days, from 1979 to his death, in October 1997. This one's from March 30 of his final year.

reasons mostly involving distribution and standardization. Polaroid lacked some of the expertise that companies like GE did at selling big equipment to medical institutions, and Helios lost ground to competing products, especially one from Kodak called Imation. It was soon spun off. A few years later, the whole field was subsumed by digital imaging.

Captiva and Helios, plus all the debt payments, ate up a lot of the Kodak settlement, which Booth admitted had largely been spoken for before it arrived. Some of the remainder of the cash was distributed to employees, out of a desire to share the big win. Yet the company's finances continued to worsen. By 1995, income had been flat for years; the loss that year was $140 million. The situation was growing urgent. Mac Booth had reached retirement age, and he and the board, for the first time, opted to place an outsider in the top job.

As was mentioned earlier, old-guard Polaroid people speak somewhat hesitantly about Mac Booth, admiring his instincts and his qualities as a person while wondering about some of his decisions. There is less ambivalence about his successor. Gary DiCamillo had come from

Black & Decker, where he'd revived a sagging company by juicing up its product development and cutting costs. At Polaroid, with its culture of pure research—expensive, unprofitable-in-the-short-term research—this was anathema. A lot of Polaroidians did not like, and still do not like, Gary DiCamillo.

Whether they liked him or not, Polaroid needed change, and many people started by giving him the benefit of the doubt. As one lifelong Polaroid engineer put it, "It was a company that was run by technical folks, and whether they made mistakes or not, the mental process was technical. I used to think that if we could figure out a way to make cameras fly, they'd agree to it. Nobody would want it, they couldn't sell it to anybody—but *Wow! What a spectacular feat!* When DiCamillo came in, it was clear that we were changing from an engineering world to a marketing world. And a lot of us thought that was what Polaroid needed."

DiCamillo immediately brought in a large team of his own. Given Polaroid's diminished state and his own track record, he broke with the company's tradition of slowly cultivating technological and aesthetic leaps: He simply wanted new stuff, lots of it, put into stores fast. "Twenty to forty new products each year" was his announced plan, and let's not have a lot of high-minded talk about the essential nature of color, please.

He was making what in hindsight appears to have been a quixotic choice. DiCamillo had a number of options open to him. He could have given up on Polaroid's consumer business, letting it trail off into digital oblivion, and instead focused on industrial applications. Though Polaroid couldn't compete with Nikon and Canon among general consumers, it had cultivated a superior base of knowledge about certain photographic specialties: scientific and microscope work, driver's license and ID systems, medical and dental imaging. There, Polaroid could dig into its knowledge base and beat everyone else to market with specialized digital products.

DiCamillo, however, wanted more than niche industries, and the way to do that was to revive the company's most familiar line, with new products and new ads.[5] The effort was all coming from the marketing and product-development side, and that same engineer who was so willing

5 One TV spot even broke the fifty-year corporate taboo, showing a sexy photo slipped into a young guy's briefcase to entice him home from work.

to give DiCamillo's team a shot saw "that they weren't very interested in the technology. I remember bringing one of the senior vice-presidents out to the factory in Waltham—we had these very large new machines, the size of a house, you actually got inside them—and I swear, I could've been showing him a Coke machine. He didn't give a damn. And the bottom line was, they weren't very good at selling stuff. They were more interested in telling you how good they were."

DiCamillo did get a lot of products out into the world—including, finally, a consumer digital camera, though it wasn't much differentiated from its competition. A lot of the new product, however, was frantic, antic repackaging of the old. A OneStep-style camera that was molded to look like the Warner Bros. Tasmanian Devil. (The pictures ejected through the mouth.) There were shoddy $25 models that took Captiva film, marketed under the odd name JoyCam. A Polaroid disposable camera appeared. So did the SpiceCam, plastered with decals of the Spice Girls pop fivesome. The OneStep Talking Camera electronically spoke silly catchphrases that were supposed to get photo subjects to smile. A scattering of the new products were aimed higher, including a neat little folding camera called the One and an awkward digital camera, produced jointly with Olympus, that printed its output on Polaroid film. Two promising inkless-printing technologies were in the works, called Opal (color) and Onyx (black-and-white). Most of the new stuff, though, was strictly at the low end.

Most of it didn't go anywhere, either, but DiCamillo expected that—this was a throw-it-against-the-wall-and-see-what-sticks strategy, and finally, something did catch on. The i-Zone camera was tiny, about the size of a desk stapler, and took integral-film pictures barely larger than a postage stamp, pulled from the camera on paper tabs. Its film was a head-ache to manufacture—the tabs were hand-folded in a low-wage factory in Mexico—but it was cute, and among teenagers and even younger kids, it took off. One version of the film allowed photos to be peeled off the tabs in sticker form, and for a while, they appeared all over school lockers and notebooks. But just as the Swinger and all the other youth-oriented Polaroid products had run out of gas, so did the i-Zone. Perhaps because it was impractical for anything beyond goofing around, the fad evaporated even faster than its predecessors had.

What everyone had missed was that the digital revolution was changing the very nature of the photograph. From the very beginning, a photograph had been a physical thing: a glass or metal plate, a negative, a slide, a piece of paper. If you didn't have that tangible object, you didn't have a photo. As Polaroid grappled with the world of digital photography, it had embraced the catchphrase "All roads lead to a print." For a century and a half, they all had.

No longer. Today, a photo is not a thing; it's a stream of ones and zeroes. Contemporary parents shoot thousands of pictures of their children, and put just a few on paper, for the bulletin board or the grandparents' mantelpiece; instead of carrying two or three in our wallets, we keep hundreds on our smartphones. After all, if your phone has an incredibly fine, bright screen, and you have it with you all the time, why mess with dyes on paper? That Olympus-Polaroid hybrid camera, as it turned out, had been pointed in exactly the wrong direction.

DiCamillo admitted it, a decade later, in an interview for the Yale magazine *Qn*: "People were betting on hard copy and media that was going to be pick-up-able, visible, seeable, touchable.... It's amazing, but kids today don't want hard copy anymore. This was the major mistake we all made. Mac Booth, Gary DiCamillo, people after me.... That was a major hypothesis, that I believed in my marrow, that was wrong."

In these years, as Polaroid struggled to figure out what it might be in the new century, DiCamillo restructured (and added to) the debt, hoping to buy time. The stock price fell to single digits. In 1998—nine years after Stanley Gold had offered $3 billion for the company, and seven years after nearly $1 billion had arrived from Kodak—the Polaroid Corporation had a market value of only $1 billion.

The headlines of the *New York Times* record what happened next. From June 2001: POLAROID TO CUT 2,000 JOBS; INSTANT-PHOTO WOES ARE CITED. A month later: BANKS GIVE POLAROID TIME TO RENEGOTIATE MILLIONS IN LOANS. (It was the third waiver that year.) Two months after that: FOR POLAROID, THE BAD NEWS SEEMS TO BE THE ONLY NEWS.[6] And finally, on page one, from October 13, 2001, a month after the attacks on New York and Washington had dumped the United States economy into a freezer: DEEP IN DEBT SINCE 1988, POLAROID FILES FOR BANKRUPTCY.

6 These very same months also marked the deaths of Polaroid's cofounders: George Wheelwright died in March 2001, at age 97, and Julius Silver the following January, at 101.

The i-Zone system was toylike, and
its pictures were barely an inch
high, but the French photographer
Steven Monteau took it in a decidedly
grown-up direction.

Rosamond Purcell, master
photographer of natural history and
decay, did much of her early work
on Polaroid film.

9 Re-vision

The road out of bankruptcy was a grubby one. In July 2002, Polaroid was sold to BankOne's investment arm, One Equity Partners, which bid $255 million for 65 percent of the company, $138 million of which was Polaroid's own cash. DiCamillo got a large payout of deferred salary, and the new chairman was Jacques Nasser, who had run Ford Motor Corporation in the late 1990s and early 2000s. It was a bargain price, and by some estimates the buyers put in just $24 million of their own, taking the company private.

How low a lowball was it? A group of investors made a case to the Securities and Exchange Commission that chief financial officer William Flaherty and his accountants had undervalued Polaroid's assets by roughly 75 percent. "We hope that you will decide to prosecute Mr. Flaherty," their lawyers wrote. A Wall Street analyst named Ulysses Yannas began writing outraged letters to the Delaware bankruptcy judge, calling the BankOne offer "grossly inadequate." According to these claims, DiCamillo and Flaherty's team had underplayed the value of the land in Waltham, overseas inventory and property, patents, and various other holdings, all so BankOne could buy the company cheaply. At the bankruptcy auction in 2002, BankOne had been the only bidder, fueling rumors that the fix was in.

The charge sounded even more plausible when BankOne flipped Polaroid three years later, in 2005, for $435 million—a 70 percent profit. Nasser got $12.8 million for his stake; his CEO, J. Michael Pocock, got $8.5 million. Many of Polaroid's 6,000 pensioners, who'd had their benefits "renegotiated" by the bankruptcy court, learned that they were getting almost nothing. The people whose ESOP purchases had kept the

company away from Stanley Gold in 1988 now got nine cents per share, for a stock that had been in the $30 range a few years earlier. Retirees losing their health-care benefits were compensated with a one-time payout of $47 apiece. To this day, it's a subject that inspires well-oiled fury all over Boston. Ultimately, the court found that Polaroid's owners hadn't acted fraudulently; they moved in greedy and ugly ways but not illegal ones. Land's tulip-bulbs-from-the-cellar approach to personnel, and Mac Booth's desire to give his workers a stake in the business, were long gone.

In their place was the new owner: Petters Group Worldwide, a Minneapolis company that specialized in wrecked companies. Tom Petters had made a lot of money a few years earlier by buying and reviving Fingerhut, a mail-order seller of inexpensive housewares. And if the Polaroid lifers hadn't thought much of DiCamillo, they were floored by Tom Petters. "He was—pardon me—an asshole," says one executive from the finance department. "When he first came to the headquarters, he called a meeting of senior Polaroid management in the cafeteria, and he had people climb up on tables and made each one sing a song. Then he'd give them ten dollars." It must have been intended as some bizarre sort of team-building exercise, but it came off like a brute expression of power: *Sing and dance for my amusement!*

Petters was not interested in instant film, the photographic arts, or imaging technology. What he wanted was the real estate, the art collection, the trademark, and the right to convert all those things into cash. Under BankOne, Polaroid had already begun putting its name on things like inexpensive DVD players and flat-panel TVs, which brought in income but did little for its future. Soon, the sunglasses operation in Scotland was spun off as its own company. Camera production ended in 2006.

As more and more of the photo business moved to digital media, people began asking: Would the company ditch its traditional money-maker? Stewart Cohen, who ran it under Petters, said no: "We'll make instant film as long as there's a market for it," he told a *New York Times* reporter. But behind the scenes, Polaroid had already killed it off. In 2004, internal forecasts had said that film sales would take ten years to trail off into nothingness. So BankOne had stockpiled a decade's worth of ingredients from Polaroid's suppliers: truckloads of dyes, tons of titanium white,

giant volumes of paper. One by one, the supply lines were allowed to dry up and the specialized production lines shut down. The miraculous New Bedford negative factory pumped out enough material to last until 2014, and was then closed and sold.

The end of instant film was fast approaching—except that over those few years, in the mid-2000s, something peculiar started to happen. Demand for Polaroid film did not fall off to zero, as Petters's people had figured. In fact, the decline began to level out. Sales were brisk enough that the ten-year supply of materials was exhausted in less than five.

Nor were sales of other analog gear disintegrating. The Diana, a plastic 35-millimeter camera made by the Russian company Lomo, was selling in puzzling numbers. So was a cheap Chinese-made medium-format camera called the Holga. They were essentially toys, but they were being bought by adults. Somehow, analog photography had become so outré that it had turned a little bit…cool.

Polaroid mania made indelible, by Jessie Barber (enthusiast and photographer) and Scott Santee (tattoo artist).

Rob Pruitt's *Andy Monument*,
with Bloomingdale's bag in Warhol's
hand and SX-70 around his neck.

Polaroid nostalgia kitsch started turning up for sale, stuff like T-shirts with pictures of SX-70 cameras on them. On Etsy, the big crafts-retailing website, someone started offering a felt plush toy in the shape of a OneStep. Here and there, you'd spot a hipster with a Polaroid-camera tattoo. Everywhere from *Time*'s celebrity-interview page to the *New York Times* real-estate section, art directors began to graft the white Polaroid frame artifically onto digital pictures, to convey "friendly snapshot." When the artist Rob Pruitt installed a chrome-plated statue of Andy Warhol in New York's Union Square in 2011, he gave his subject two props: a Bloomingdale's shopping bag in his right hand, and an SX-70 camera on a strap around his neck.

It was not an unprecedented phenomenon. A similar small-scale revival had happened a few years earlier with the vinyl record, a format that, in the early 1990s, was absolutely moribund. A decade later, club deejays were spinning LPs all over the world, and if you went to one of the urban-center incubators of hipness—someplace like Brooklyn or Portland—you'd find honest-to-god record stores, with bins full of shrink-wrapped 12-inch discs, as if it were 1977.

Some of these analog enthusiasts merely enjoyed putting distance between themselves and their peers, but that wasn't (and isn't) the only thing going on. When most every bit of information you see and hear every day is digital, the great mass of it appears consistent and uniform. Digital TV has no snow; digital music (unless you're a true audiophile) sounds flawless. That eerie near-perfection leaves many people feeling a little bit numb, craving something unpredictable. Polaroid snapshots certainly qualify, and the mystique of the instant picture grew deeper even as its future grew doubtful.

In February 2008, that doubt turned into certainty. The supplies were drained, and Polaroid quietly announced that it was done with film. The final batches were going to pass their use-by date in the fall of 2009. Fujifilm did some negotiating to buy Polaroid's packfilm business, suggesting that it would take over production on its machinery, then backed off at the last moment. By the time that discussion ended, Polaroid had demolished its own equipment, so it could be written off.

The reaction was immediate and fierce. "It's not replaceable, and they're leaving it like roadkill," roared Chuck Close. "These corporate raiders who buy a company and strip it for everything profitable—they just pick the bones." A performance artist named Lynnette Astaire scheduled a mock funeral, to march through the streets of downtown New York. John Waters, the film director who embraced instant cameras' porny aspects as well as its practical ones, phrased the feeling best: "The world is a terrible place without Polaroid." The celebrity portraitist Timothy Greenfield-Sanders one-upped him, saying "It's the worst disaster since Hiroshima." People began buying up the last film, even hoarding it. Greenfield-Sanders stuffed $5,000 worth of large-format Type 809 into a refrigerator in his basement. Petters's executives,

realizing their mistake, went back to their technicians, saying "can we start everything up again?" The answer, on every front, was no: No machinery, no dyes, no negatives—no chance.

Within months, Fujifilm's Instax instant cameras, long available in Japan under that old agreement with Polaroid, began to make their way to the United States. Their film was not compatible with any of Polaroid's, however, so photographers couldn't keep using their SX-70s. They had to buy Fuji's own cameras, which were serviceable but not much better than the Pronto! had been.

That was cold comfort for John Reuter, who had been busily running the 20x24 camera operation in New York. He'd been given discreet notice that the end was near, and around 2006—prodded by Elsa Dorfman, the Cambridge photographer who rented one of the other 20x24 cameras—he began arranging to spin off the studio as its own company. In 2008, bankrolled by a venture capitalist and friend of Dorfman's named Dan Stern, Reuter formed 20x24 Holdings LLC, and bought about six years' worth of film and paper from Polaroid. The pod-filling machine and the reactor that made the goo soon made their way to a new home in Connecticut. There, Reuter and a couple of associates had to figure out how they worked, reconstructing the recipe for the reagent from scratch, based on fragmentary recipes and the collective memory of several Polaroid retirees. One of them, Ted McLelland, ended up making test batches himself in a Waring blender.

Websites saluting everyone's favorite endangered species of photography began to appear, and one stood out: SavePolaroid.com. It had been cofounded by David Bias, a New Yorker who took an interest in elegant outlier technologies, and he and his partners intended, at the beginning, to coax Polaroid into reversing its decision. As the nature of the shutdown became evident—that it had been years in the making, and was irreversible—SavePolaroid turned into more of an activist site, trying to find a buyer for Polaroid's machinery.

In fact, all the factories might have been liquidated and demolished right away, but Polaroid's management was distracted, for a reason nobody might have predicted: In October 2008, Tom Petters was arrested on charges of fraud. He was alleged to have stolen $3.65 billion worth

of financing raised for nonexistent companies, in a matter unrelated to Polaroid, and he was caught by an FBI sting operation straight out of the movies—hidden microphones, wiretaps, the whole shebang. It turned out that his "success" with Fingerhut had been a mirage built on creative bookkeeping, and that the underlying reason for converting Polaroid's assets into cash was to sustain his Ponzi scheme. In 2010, he was sentenced to fifty years in prison.

Partly to keep its distance from Petters's liabilities, Polaroid filed for bankruptcy a second time, and in April 2009, the company he had bought for $426 million was sold at auction for just $85.9 million. The winners were two companies, Hilco and Gordon Brothers, that planned to run Polaroid as a joint venture. (Though Hilco/Gordon Brothers had been slightly outbid by the brash New York private-equity investor Lynn Tilton, the judge and the creditors went with them anyway, reportedly because they were turned off by Tilton's mouthy, profane behavior in court.)

One thing the new owners didn't get was the art collection, and in June 2010, a chunk of it—about 1,200 of the 16,000 photos in the American collection—was sold off at Sotheby's "by order of the United States Bankruptcy Court for the District of Minnesota." The pieces in the auction had seemingly been selected for their marketability, and whoever did the selecting did it well. A small group of portraits of Ansel Adams by other prominent photographers, estimated at $2,000 to $3,000, went for $20,000. An enormous Chuck Close composite—a grid of nine 20x24 prints—sold for nearly $300,000. One Warhol sold for nearly twenty-five times its estimate, and an enormous Ansel Adams print, *Clearing Winter Storm, Yosemite National Park*, broke the artist's record, reaching $722,500. Three more Adamses reached the half-million-dollar range. The Polaroid Collection pedigree wasn't the only thing driving the prices, but it helped. The take was an affirmation of Polaroid's mystique, and a sad day for anyone who wanted to see the collection kept whole, the final slashing gesture in Petters's plan to carve up the company.[1] Many of the artists were angry about it, too. Chuck Close insisted to a London reporter that "These were not Polaroid's works to sell. I gave my best work to the collection because it was made clear that it was going to stay together."

[1] The following summer, nearly all the remainder of the American section of the collection—roughly 10,000 works—was sold en masse to an American collector named Nathan Bruckner. He is in the real-estate business, and reportedly plans to exhibit the collection in one of his New York buildings.

Almost nobody has much good to say about Tom Petters. (One photography website has attempted to promulgate the verb "petter," meaning "needlessly destroy.") But, strangely, Polaroid enthusiasts do owe him one thing: His trial and the associated bankruptcy brought some disarray, and the old business wound down in fits and starts. That bought a little time, and it turned out that David Bias wasn't the only guy trying to save Polaroid film. Two men more than 3,000 miles away from Waltham, one of them within Polaroid itself, also had the idea that it might not be a completely settled matter.

André Bosman, in almost three decades at Polaroid, had risen to become manager of the Enschede film plant, in the Netherlands. Now he was charged with its closure. One Friday that spring, he sat down for a Friday drink with an Austrian named Dr. Florian Kaps. Trained as a neuro-biologist specializing in spiders, of all things, Kaps had spent the past several years marketing those toylike Lomo cameras from Russia, success-fully enough that "Lomography" became the widespread term for this kind of analog-retro picture-taking. He'd had been badgering Polaroid's management about keeping the factory going, and Bosman was supposed to go tell him to cool it.

The way they tell the story, the two were both moaning about the end of Polaroid film. Kaps was fatalistic, since (he'd heard) the real estate under the factory had been sold for redevelopment. No, Bosman told him—the land had been sold, but the collapse of the housing market had delayed the investors' plans for ten years. The two looked at each other, and, as Kaps later told *Wired* magazine, "we stopped drinking beer."

They had to move swiftly: It was Friday afternoon, and the scrapping of most of the irreplaceable machinery was to begin on Monday morning. Kaps and Bosman spent the weekend frantically lining up money, cajoling and ultimately threatening Polaroid's executives with a public humiliation along the lines of "we wanted to save this product everyone loves, and you people killed it." The liquidation had stalled anyway, and Polaroid agreed to sell the plant's contents, and lease the building, to Bosman and Kaps.

They and a financier named Marwen Saba incorporated as the Impossible Project, a name drawn from Land's "manifestly important and nearly impossible." Nearly, and maybe completely: They had no

negatives, no dyes, no batteries, no suppliers, nothing but a rain-streaked silent factory.

Bosman and Kaps rehired about a dozen laid-off Polaroid people and got to work. Black-and-white film was first on the plans, to be followed by color. They had enough money to spend a year or so getting up to speed, and Kaps had already bought up the last of Polaroid's film to sell, giving the startup a financial cushion. A few months later, Kaps hired Bias and his girlfriend, Anne Bowerman, to start a U.S. office. Initially, it was run out of their New York apartment, where they lived surrounded by crates

The Impossible Project's first efforts were pretty (if you were patient and a little lucky).

of not-quite-expired film. They soon rented a SoHo loft office that had enough room for a gallery and shop.

And, come March 2010, Kaps and Bosman stood before the press in that loft, each holding an SX-70 loaded with new film. Kaps explained that they hadn't been able to use the old recipe. One ingredient, the inky red sealant at the edge of the pod, had been banned by the European Union for its carcinogenic properties. The old opacifier had turned out to be flat-out irreproducible. Polaroid's unique negative was gone for good. The three color dyes were likewise unavailable, and it was going to take a couple of years to brew them anew. Because of various workarounds the Impossible people had developed, the new film was slightly thicker than the old—there were eight shots in a pack instead of ten. To cap off the press conference, Kaps shot a black-and-white photo of Bosman. As it popped out of his camera, he abruptly snapped it facedown against his jacket, and slipped it into his pocket, revealing it a few minutes later.

In the next few days, jubilant stories zinged their way through the press: *Polaroid film is back!* It wasn't cheap—$21 for those eight shots—but people queued up to buy it. And the film itself was... well, experimental. A work in progress. "Creamy-dreamy" was how one buyer described his photos. They were brownish-beige, with white specks. The contrast was low. The opacifier—though it was a beautiful sapphire blue—was not quite lightproof, so the only way to get a photo was to cover the film immediately as it ejected, as Kaps had. Users were advised to tape an empty film box to the front of the camera, to catch the photo before light struck it. Some early film batches were inadequately sealed, and smeared goo all over the camera's works when the photo ejected. Sometimes the developer paste spread unevenly, leaving a blank patch. After development, the chemistry often crystallized after a couple of weeks, destroying the image altogether. Developed above 75 degrees Fahrenheit, the pictures turned reddish. Below 60, they turned yellow-white.

Impossible's initial batch had been given the moniker "First Flush," a heavy hint that it wasn't yet where it needed to be. The marketing materials, too, emphasized the film's unpredictability, spinning it as an "analog adventure." You had to be a true believer—and have a certain amount of luck—to get and keep a decent photograph. The company began issuing

elaborate instructions with each pack: slice open the pod after shooting to let humidity escape; pack your photos with silica gel to dry them; shoot into a bag or box; keep new photos in a warm pocket in winter, and carry an ice pack in summer; rap every fresh film cartridge against your hand, the way smokers tamp their cigarette packs, to make sure the film sheets weren't stuck inside. A lot of buyers found this maddening, particularly at nearly $3 per shot.

On Flickr, a major website for photography enthusiasts, the instant-photography discussion groups lit up with enthusiasm and gripes in equal proportion. People got into arguments over whether Impossible was a triumph or a joke. One could be forgiven for believing that the company's name had turned out to be accurate, and for asking whether these crazy people would soon be out of business.

Except that the next batch of film, released a month later, was a little better: more light resistant, higher contrast, generally cleaner looking. The crystallization problem eventually got solved, mostly. The white specks disappeared. By the end of 2010, the monochrome film was not bad at all—you didn't have to shoot it into a box, except in bright sun—and a new First Flush color film had made its debut. The tones were restrained and undersaturated, and it was still light- and temperature-sensitive, but it was *there*. You could once again use your SX-70. Romantics—a category that encompassed nearly everyone who was willing to deal with this product's limitations—could persuade themselves that the Impossible Project was retracing Polaroid's initial difficulties. Kaps was fond of pointing out that the first Type 40 film, in 1948, had contained eight sepia images per package, just like Impossible's. "People are trying to *beat* the film!" he once said, sounding delighted that its flaws were being treated as challenges.

Was shooting into a cardboard box much more complicated than swabbing on some film coater? Probably. Yet for Impossible's hardcore customers, the film's twitchiness was half the point. If you never quite knew what you were going to get, the perfect picture was that much more extraordinary, and some of the imperfect ones were beautiful in their own way. Fuji's Instax system was far more stable and even-tempered, and got most of the old industrial business of insurance adjusters and cops; Impossible's film became the anointed successor to Polaroid's artier side,

and drew on the deep well of Pola-love. It continued to get better, too. By early 2012, although it was still only a product for believers, Impossible's color began to look a lot like Polaroid's. When pressed, the employees hinted that a new and better class of opacifier dyes was in the works, and that a straightforwardly usable product was on its way.[2] So was a new Impossible camera, to be produced in Germany.

Another revivalist program had begun, too, this one just down Route 128 from Polaroid's old Waltham campus. A fellow named Bob Crowley who was in the high-performance-microphone business began trying to make an equivalent to Polaroid Type 55, the large-format positive-negative film that Ansel Adams had pushed for and so many photographers had loved. Crowley faced a different set of problems from Impossible's, with less capitalization and an even smaller niche. "This is an enthusiasm, not a business," he admits. But that market was willing to pay a lot for a Type 55 replacement, and by late 2011, he'd triumphantly displayed a high-quality negative on his blog, one that he'd just processed through the rollers of a Polaroid camera back. He, too, was keeping a little slice of Polaroid alive.

By the time Impossible and Crowley got their projects going, Hilco and Gordon Brothers had found their CEO for Polaroid itself. Bobby Sager was an unusual guy, one who'd worked for Gordon Brothers since the mid-1980s. After about fifteen years, he'd quit, turning the next decade of his life over to philanthropy in places like Rwanda and palling around with rock stars like Sting. Sager had thought he was through with corporate life, and then learned that, in his words, "this brand could be bought for many, many, many, many times less than it was worth." He'd also been a professional photographer at one point, which can't have hurt his interest in Polaroid, and he'd even grown up in Boston.

Sager is not a nostalgist, and has repeatedly said "I'm not in this for a walk down memory lane." His Polaroid will remain largely a company that puts its brand on products made by others. He and Impossible cultivated a relationship, but he wasn't about to jump in and start manufacturing film. What Sager did understand was that Polaroid, in order to recover, had to find itself a unique new business. Edwin Land's mission statement ("Don't do anything that someone else can do") was still good strategy. Sager

2 In the summer of 2011, Impossible also cemented its connection to Polaroid's artistic legacy, joining with the WestLicht gallery, a photography museum in Vienna, Austria, to buy the European portion of the Polaroid Collection and keep it intact.

The Impossible Project's color:
imperfect, but vibrant.

says "I'm not interested in slap-branding," by which he means sticking a Polaroid label on an ordinary DVD player. If he's going to market a product, he says, "there has to be something 'Polaroid' about it."

He knows perfectly well that Polaroid is known almost solely for analog photography, and soon after he took over, one of his licensees, Summit Technologies, announced a new camera along the lines of the OneStep. (It never made it into production; Summit turned out to be undercapitalized.) A few months later, Polaroid and Summit "reintro-duced" Polaroid instant photography, with a chunky little camera that made small integral-film photos, about the size of the Swinger's. It turned out to be Fuji's Instax Mini, relabeled.[3] The Instax line had been sitting in photo stores, mostly ignored. As soon as it was renamed "Polaroid," it was picked up by huge discounters like Target and started to sell. The word still carried its old mystique, even if the product was someone else's entirely. Summit even tried, and failed, to bring back i-Zone film.

The big play for Sager's company, though, was not film but a tech-nology called Zink, short for "zero ink." It had been in development for about a decade, with its origins in the pre-bankruptcy Polaroid, and was spun off by a team of employees in 2005, when Petters didn't want to spend millions developing it. A Zink printer uses no cartridge or ribbons. Instead, a sheet of paper contains three layers of microscopic crystals (cyan, magenta, yellow) that turn from clear to bright color when heated to precise temperatures. Move a print head over the sheet, precisely heating it pixel by pixel, and you create an image. It's clever and unique—just the sort of thing Land might've liked to see percolating around the labs.

The Zink printer was first sold in 2008, under the name Polaroid PoGo, and its photos were small and somewhat grainy. The printer itself was no bigger than a deck of cards, though, and it allowed you to do many of the things a Polaroid camera had—especially printing a photo on the spot to give it away. Quite a few people, upon seeing a Zink printer, offer the same thought: Why not mount the printer on a camera so the photo comes out a slot at the bottom? It'd be almost like a…well, you know.

A prototype for that very product made its appearance at the 2011 Consumer Electronics Show. It was part of an extremely splashy event put

3 Irony alert: Polaroid had ended up selling a camera based on the Kodak system, which it had spent years trying to crush.

on by Polaroid, and at its center was a scene that would have flabbergasted the somewhat prudish Stan Calderwood. A year earlier, Polaroid had hired as its public face the outrageously sexualized, insanely costumed pop singer Lady Gaga. Moreover Polaroid wasn't calling her its spokesmodel; Sager had given her the title of creative director, and she sent out a photo (via Twitter) in which she flashed her business card to prove it.

At CES, Lady Gaga introduced a line called Polaroid Grey Label, including the new camera, a bigger Zink printer that made much sharper prints, and pair of sunglasses that could snap digital pictures from a wearer's-eye view. Gaga (and Sager) swears that she had a significant hand in the product designs, and she talked about them with enough detail that you could half-believe it.

Sager's team, joined by Gaga, even made a pilgrimage to Cambridge for a public-relations event linking the new Polaroid to the old. In 2010, the company's seventy-five years' worth of prototypes and other physical artifacts were donated to the MIT Museum (which is about 500 feet from the Osborn Street lab). To mark the transfer, Lady Gaga dropped by the museum, and a 20x24 camera made a special trip from New York. She slipped on some vintage polarized sunglasses and sat for her portrait in Edwin Land's battered leather swivel chair.[4] Sure, this was a stunt: Land's ethos resided in his wildly inventive brain and his philosophy of business and science, not in his furniture. But as stunts go, it was a great one.

Watching this looking-forward-and-back exercise, you could wonder what Polaroid is today. To be sure, it is nothing like the company Land and McCune and Booth ran. It is mostly built around leveraging that evocative old name. It has about thirty employees, and nobody there is doing studies on the elemental nature of color vision. It doesn't even own Zink, the technology it sells.

Yet, having been hollowed out and stripped for parts by Petters, it had nowhere to go but up. With Impossible effectively conserving a chunk of its analog past, Polaroid's new management is attempting to look forward again. Ask Sager about what comes after the new printers and cameras, and he is wide open: "Ninety percent of what we're going to be selling in three years hasn't been invented yet." He's not a scientist, and, when pressed, admits that he has little idea what those products will be. He doesn't know

4 John McCann, when I told him about this, immediately asked me, "Was it the Barcalounger?" Sadly not.

Improbable partners: The MIT
Museum, Edwin Land's office chair,
and Lady Gaga converged in
June 2011.

much about Edwin Land, beyond a few respectful anecdotes, and frankly, he doesn't need to. Ask him about what Polaroid is, and he reveals an understanding of what instant pictures do to people. "Sharing" comes up a lot, and he explains that some of those mysterious future products will not be physical—they will be connected to the photo-swapping that goes on via social networks like Facebook, which is generally held to be a growth business. "The original social networking" is one of Sager's catchphrases, and so is "The tablet computer is Polaroid." He's right, too. (It's a shame he hadn't come along a little earlier. About Petters's closing down the film business, he says, "I wouldn't have done it. It needed to be rethought, but no. Besides, as a photographer, I probably wouldn't have had the heart.") For 2013, Polaroid's big push is in 3-D television. Amazingly, the successor to Land's most profitable invention has turned out to be his original one: Every pair of 3-D glasses incorporates a pair of polarizers.

It won't ever be the old Polaroid again—that will take an idea the size of Google, and those are mighty scarce. Besides, even the world's most surefooted patent lawyers can no longer secure decades to build a company. Great ideas now get leapfrogged in four years, not forty. All the same, Polaroid may, improbably, implausibly, have a shot at being something small and interesting again.

It's more than a camera—it's almost alive.

Bibliography

The bibliography that follows lists only published material. My own interview subjects are credited in the text and in the acknowledgments. The primary unpublished source was Polaroid's giant corporate archive, now safely housed in the Baker Library Historical Collections at Harvard Business School.

Much information also came from Polaroid's corporate annual reports, a nearly complete run of which is also available at Baker Library, and from the company's in-house *Polaroid Newsletter* (later called the *Polaroid Update*). Other unpublished sources include the papers of Vannevar Bush, in the Manuscript Division of the Library of Congress; the archives of Henry Dreyfuss Associates, at the Cooper-Hewitt, National Design Museum in New York; and the Lyndon B. Johnson Library and Museum, in Austin, Texas.

In the matter of *Polaroid v. Kodak*, the three principal judgments (by judges Zobel, Markey, and Mazzone) are readily available through Google Scholar.

Among the many websites devoted to Polaroid photography, two stand out. The Land List (www.landlist.org), run by Marty Kuhn since 1993, is packed with information. Instant Options (www.instantoptions.com) mirrors and amplifies the Land List, adding lots of up-to-date detail about camera, battery, and film availability. Those interested in shooting instant film today are encouraged to spend some time at both sites, and on the discussion boards devoted to Polaroid and the Impossible Project at Flickr (www.flickr.com).

I have also heavily drawn from decades of steady Polaroid coverage in the *New York Times* and *Time*, both of which are searchable online (at www.nytimes.com and www.time.com) and thus will not be cited.

BOOKS

Adams, Ansel. *Polaroid Land Photography*. Boston: New York Graphic Society, 1963, 1978.

———. *Polaroid Land Photography Manual*. New York: Morgan & Morgan, 1963.

———. *Singular Images*. Boston: New York Graphic Society, 1974.

Carr, Kathleen Thormod. *Polaroid Transfers: A Complete Visual Guide to Creating Image and Emulsion Transfers*. New York: Amphoto/Watson-Guptill, 1997.

Cosindas, Marie. *Color Photographs*. Boston: New York Graphic Society, 1978.

Earls, Alan R., and Nasrin Rohani. *Images of America: Polaroid*. Charleston, S.C.: Arcadia Publishing, 2005.

Evans, Harry, Gail Buckland, and David Lefer. *They Made America*. New York: Knopf, 2004, 384–88.

Giambarba, Paul. *The Branding of Polaroid*. Revised edition privately printed by Giambarba, 2010.

———. *How to Make Better Polaroid Instant Pictures*. Garden City, N.Y.: Giambarba/Doubleday, 1970.

Gurbo, Robert, and Eelco Wolf. *André Kertész: The Polaroids*. New York: W. W. Norton, 2007.

Hitchcock, Barbara. *The Polaroid Book: Selections from the Polaroid Collections of Photography*. Edited by Steve Crist. Cologne: Taschen, 2005, new edition 2008.

Hitchcock, Barbara, Deborah Klochko, Deborah Martin Kao, and Charles Cunningham, introductions and essays in *Innovation/Imagination: 50 Years of Polaroid Photography*. New York: Abrams, 1988.

Ings, Simon. *A Natural History of Seeing*. New York: W. W. Norton, 2008.

Isaacson, Walter. *Steve Jobs*. New York: Simon & Schuster, 2011.

Land, Edwin H. *Edwin H. Land's Essays*. Edited by Mary McCann. Springfield, Va.: IS&T—Society for Imaging Science and Technology, 1993.

———. *The SX-70 Experience*. Unmarked, but most likely produced by Polaroid Corporation, 1974.

Levinthal, David. *American Beauties*. Santa Monica, Calif., and New York: Pence Gallery and Laurence Miller Gallery, 1990.

Livesay, Harold C. *American Made: Men Who Shaped the American Economy*. New York: Scott, Foresman/Little, Brown & Company, 1979.

McElheny, Victor. *Insisting on the Impossible: The Life of Edwin Land*. Reading, Mass.: Perseus Books, 1998.

Olshaker, Mark. *The Instant Image*. Briarcliff Manor, N.Y.: Stein & Day, 1978.

Owen, David. *Copies in Seconds*. New York: Simon & Schuster, 2004.

Purcell, Rosamond Wolff. *Half-Life: Photographs*. Boston: David R. Godine, 1980.

Rosenheim, Jeff L. *Walker Evans: Polaroids*. Zurich: Scalo, 2002.

Samaras, Lucas. *Photo-Transformations*. New York: E. P. Dutton, 1976.

Smith, Patti. *Just Kids*. New York: Ecco/HarperCollins, 2010.

Van Sant, Gus. *One Step Big Shot*. Portland, Ore.: Nazraeli Press, 2010.

Wensberg, Peter C. *Land's Polaroid: A Company and the Man Who Invented It*. Boston: Houghton Mifflin, 1987.

Wolbarst, John. *Pictures in a Minute*, 3rd ed. New York: American Photographic Book Publishing Co., 1960.

———. *Polaroid Portfolio #1*. New York: American Photographic Book Publishing Co., 1959.

Wolf, Sylvia. *Polaroids: Mapplethorpe*. Munich: Prestel Verlag, 2007.

Wood, R. W. *Physical Optics*. 2nd ed. New York: Macmillan, 1911.

Wurman, Richard Saul. *Polaroid Access: Fifty Years*. N.P.: Access Press/Polaroid Corporation, 1989.

JOURNALS, NEWSPAPERS, and MAGAZINES

Alster, Norm. "Double exposure." *Forbes* (September 14, 1992).

Armstrong, Scott. "The ultimate box camera." *Christian Science Monitor* (March 26, 1981).

Bailey, Steve, and Steven Syre. "In hindsight, perhaps Polaroid should have sold." *Boston Globe* (October 22, 1998).

"Bankruptcy Beat Snapshot: Gary DiCamillo." *Wall Street Journal* (February 5, 2010).

Bello, Francis. "The Magic That Made Polaroid." *Fortune* (April 1959).

Bernstein, Jeremy, "I Am a Camera." Review of *Land's Polaroid: A Company and the Man Who Invented It,* by Peter C. Wensberg. *New York Review of Books* (April 14, 1988).

Biddle, Frederic M. "Europe cited in Polaroid woes." *Boston Globe* (January 22, 1993).

Blout, Elkan. "Polaroid: Dreams to Reality." *Daedalus* 125:2 (Spring 1996): 39–54.

Byrnes, Nanette, and Adrienn Hardman. "Cold Shower: Why Polaroid shareholders can thank Roy Disney for his aborted takeover." *Financial World* (September 28, 1993).

Callahan, Sean. "Dr. Land's Latest Bit of Magic." *Life* (October 27, 1972).

"Camera Coughs Out Finished Prints." *Popular Science* (April 1947).

Carlisle, Norman. "Wizard of Light." *Coronet* (April 1946).

Chakravarty, Subrata. "An Interview with Dr. Edwin Land." *Forbes* (June 1, 1975).

———. "The Vindication of Edwin Land." *Forbes* (May 4, 1987).

Coffey, Brendan. "Levitating a Fallen Angel." *Forbes* (November 25, 2002).

Cortdz, Dan. "How Polaroid Bet Its Future on the SX-70." *Fortune* (January 1974).

"Depth." *New Yorker* (May 16, 1953).

Dorfman, Dan. "Is Polaroid Through on Wall Street?" *New York* (August 26, 1974).

"Dr. Land Redesigns His Camera Company." *Business Week* (April 15, 1972).

"Energy." *New Yorker* (December 5, 1959).

Frieswick, Kris. "What's Wrong With This Picture?" *CFO Magazine* (January 1, 2003).

Garud, Raghu, and Kamal Munir. "From transaction to transformation costs: The case of Polaroid's SX-70 camera." *Research Policy* 37 (2008), 690–705.

Gilbert, Sarah. "Picture This: The Impossible Project That Kept Polaroid Film Alive." Dailyfinance.com (March 2, 2010).

"In the Light of Polaroid." *Fortune* (September 1938).

Kerr, Alix. "What It Took: Intuition, Goo." *Life* (January 25, 1963).

Krasner, Jeffrey. "DiCamillo Quits Polaroid: Embattled CEO Ends 6-Year Run." *Boston Globe* (May 9, 2002).

———. "Polaroid Announces Resignation of Three Executives." *Boston Globe,* (October 30, 2001).

———. "Polaroid Sale Worth $47 to Each Retiree." *Boston Globe* (April 27, 2005).

"Ladies' Day at Polaroid." *Forbes* (July 1, 1954).

Land, Edwin H. "Experiments in Color Vision." *Scientific American* (May 1959).

"Land bows out before the cameras." *Economist* (July 31, 1982).

"Land of Hope and Polaroid." *Economist* (October 30, 1976).

"Land's New Wonder." *Newsweek* (May 9, 1977).

"Light Control." *Life* (February 7, 1944).

Manchester, Harland. "Pictures in 60 Seconds." *Scientific American* (April 1947).

"Marketing a Camera Revolution." *Business Week* (June 12, 1954).

Marquard, Bryan. "Eudoxia Woodward, 88; painter merged science, art." *Boston Globe* (January 22, 2008).

McGinn, Daniel. "A Camera for a New Generation." *Newsweek* (April 29, 1996).

McKeon, Nancy. "Instant Andy." *New York* (November 17, 1980).

McWilliams, Gary. "Larry, We Hardly Knew Ye." *Business Week* (December 27, 1993).

———. "A Radical Shift in Focus for Polaroid." *Business Week* (July 26, 1993).

Negri, Gloria. "Peter Wensberg, 77; headed Polaroid marketing in 1970s." *Boston Globe* (November 14, 2006).

"Now It's 60-Second Pictures in Color." *Life* (January 25, 1963).

Nulty, Peter. "The New Look of Photography." *Fortune* (July 1, 1991).

Ozanian, Michael K. "Darkness Before Dawn." *Financial World* (June 6, 1995).

Palmer, Jay. "Spending Kodak's Money." *Barron's* (October 7, 1991).

Perry, Nancy O. "Snapshot: Gary DiCamillo, Polaroid's CEO." *HBS Bulletin* (April 1998).

Perry, Tekla S. "Zink: Inkless Printing With Colorless Color." *IEEE Spectrum* (November 2009).

"Picture of the Week." *Life* (March 3, 1947).

"Polaroid Announces Second Quarter Results." *PR Newswire* (July 20, 1993).

"Polaroid Corporation: Shareholder's Letter Discusses Company's Prospects." *PR Newswire* (June 27, 1995).

"Polaroid; set to a faster speed." *Economist* (May 3, 1986).

"Polaroid; Sharper focus." *Economist* (April 24, 1993).

"Polaroid: Turning away from Land's one-product strategy." *Business Week* (March 2, 1981).

"Polaroid v. Kodak; Landmark case." *Economist* (October 17, 1981).

"Polaroid's Click—Color Photos in 50 Seconds." *Newsweek* (January 28, 1963).

"Polaroid to lay off 2,000 employees." *Digital Photography Review* (June 13, 2001).

"Polaroid's search for Helios partner finds match in Sterling Diagnostic." *Diagnostic Imaging* (November 6, 1996).

Pritchard, Timothy. "Decline of once buoyant Polaroid reflects firms' dependence on a single product line." *Globe and Mail* (March 17, 1980).

"R. R. Wareham, Helped Design Polaroid SX-70." *Boston Globe* (August 21, 1999).

Scanlon, Jessie. "Flash Forward: Polaroid's Five-Year Plan." *Wired* (September 2001).

"Scanning the Field for Ideas: How Polaroid's Billfold-Size Camera Works." *Machine Design* (June 25, 1970).

Schiffres, Manuel. "Investment Update: Polaroid's Hidden Value." *Changing Times/Kiplinger's Personal Finance* (June 1990).

Seeman, Jeffrey I. "The Woodward-Doering/Rabe-Kindler Total Synthesis of Quinine: Setting the Record Straight." *Angewandte Chemie International Edition.* 46 (2007): 1378–1413.

Siekman, Philip. "Kodak and Polaroid: An End to Peaceful Coexistence." *Fortune* (November 1970).

Smith, Andrea Nagy. "What Was Polaroid Thinking?" *Qn* (Fall 2009).

Sonnenfeld, Jeffrey. "The Genius Dilemma." *Newsweek* (January 23, 2011).

TParadiso. "The Battle for Business Ethics: Polaroid's Final Days Come Into Focus." The Motley Fool, www.fool.com (August 26, 3003).

Tripsas, Mary, and Giovanni Gavetti. "Capabilities, Cognition, and Inertia: Evidence from Digital Imaging." *Strategic Management Journal* 21 (2000): 1147–61.

"USA company: Little hope for Polaroid shareholders." *EIU Newswire.* Reprinted from *CFO Magazine* (October 27, 2003).

Van Voris, Bob. "Petters Should Get 335 Years for Fraud, U.S. Says." *Bloomberg Businessweek* (March 8, 2010).

Whitford, David. "Polaroid, R.I.P." *Fortune* (November 12, 2001).

"Why Polaroid Must Remake Itself—Instantly." *Business Week* (September 19, 1988).

Wright, Mic. "The Impossible Project: Bringing Back Polaroid." *Wired UK* (December 2009).

ADDITIONAL SOURCES

Brown, Lew G., and David R. Vestal. "Polaroid and the Family Imaging Market." Case study prepared for University of North Carolina at Greensboro, 1995.

Conversations with Ansel Adams: oral history transcript. MSS 88/28, The Bancroft Library, University of California, Berkeley.

Garrelick, Renee. "Concord Oral History Program: William McCune." Interviewed July 11, 1996, and accessed in the fall of 2010 from www.concordlibrary.org.

Mims, W. Andrew. "Polaroid 2001: The i-Zone Brand." Case study prepared for Tuck School of Business at Dartmouth, April 2001.

Tripsas, Mary. "World Wide Licenses Ltd.: From Disney to Polaroid." Case study N9-805-060 prepared for Harvard Business School, October 19, 2004.

Acknowledgments

Thanks for the stories and pictures:

William Anastasi
Phil Baker
Al Bellows
David Bias
Anne Bowerman
Sheldon Buckler
David Byrne
Leslie Calmes
Michael Cardinali
Kathleen Carr
Tammy Carter
Chuck Close
Marie Cosindas
Edward Coughlan
Hugh Crawford
Donald Dery
Ian Dickerson
Mark Dionne
Ken Fernandez
William Field
Ron Fierstein
Genevieve Fong
Rich Garabedian
Stanley Gold
John C. Goodman
Manfred Heiting

David Hertsgaard
Florian Kaps
Marlene Kelnreiter
Danny Kim
David Levinthal
Jim Linderman
Christophe Madamour
Allison Matthews
John and Mary McCann
Jennifer McFarland
Jeffrey Miller
Steven Monteau
Louise Morse
Mark Olshaker
Sarah Hollis Perry
William Plummer
Rosamond Wolff
 Purcell
Cecil Quillen Jr.
Stevie Remsberg
John Reuter
Olivia Romeo
Tish Rosales
Robert Ruckstuhl
Nancy Lane Rudolph
Bobby Sager

Lucas Samaras
Herbert and Nan
 Chequer Schwartz
Mark Sink
Joseph Slade
Dennis Slafer
Bert Stern
Jason Sutton
Phil Taubman
Giovanni Tomaselli
Jennifer Trausch
Gus Van Sant
Michael Viola
Vivian Walworth
Bill Warriner
Lucretia Weed
William Wegman
Eric R. A. Woodward
Eelco Wolf
Sam Yanes
Ulysses Yannas

Thanks also to:

Nicola Bednarek Brower, who said yes
Connie and Peter Bonanos, who were there first
Ann Clarke and Mary Kaye Schilling, who bent the rules
Doug Clouse and Angela Voulangas, who made it look fantastic
Kris Dahl, who believed
Lawrence Fong, who wrangled
Boris Kachka, who read it first
Victor McElheny, who knows everything
Adam Moss, who taught
Fran and Frank McDermott, who got me a lot of Saturdays
David and Betsy McDermott, who put me up (you too, Kendall and Matt)
Dan Simon, who made it much better
Ann Smith and Sam Seidel, who played St. Bernard in a blizzard
Stephen Soba, who had no idea what he was starting
Joseph Twichell, who played emergency messenger
Katie Van Syckle, who took it digital

Extra-special gratitude to those who went above and beyond the call:

Ted Voss, keeper of the language (then and now)
Dr. Deborah G. Douglas, at the MIT Museum
Tim Mahoney and the Historical Collections staff of Harvard Business School's
 Baker Library
And most of all, the Michael and Carole Greenfield Visiting-Scholar Program
 and On-Call Taxi Service, of Norwood, Massachusetts.

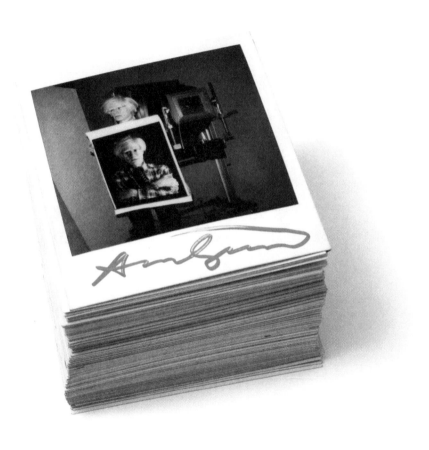

IMAGE CREDITS

FRONTISPIECE: © Bill Ray

CHAPTER 1
page 6: © Co Rentmeester/Time & Life Pictures/
Getty Images. page 9: Walker Evans, *Detail of
Parking Lot Office Door*, 1974; The Metropolitan
Museum of Art, Purchase, Samuel J. Wagstaff
Jr. Bequest and Lila Acheson Wallace Gift, 1994
(1994.245.59). page 10: Walker Evans, *Painted
Advertisement for the Marquezette Lounge,
Marigot, French West Indies*, 1973–74; The
Metropolitan Museum of Art, Purchase, Samuel J.
Wagstaff Jr. Bequest and Lila Acheson Wallace Gift,
1994 (1994.245.53). *Theater Near Old Saybrook,
Connecticut*, 1973; The Metropolitan Museum of
Art, Purchase, Samuel J. Wagstaff Jr. Bequest and
Lila Acheson Wallace Gift, 1994 (1994.245.130).
© Walker Evans Archive, The Metropolitan
Museum of Art. page 12: William Wegman, *Fay
and Andrea* (1987). Courtesy of William Wegman.
page 13: Robert Mapplethorpe, *Patti Smith, 1973*,
© Copyright The Robert Mapplethorpe
Foundation. Courtesy Art + Commerce. page 16:
top, Stevie Remsberg; *bottom*, © 2011 Michael
Cardinali/Courtesy of the MIT Museum. page 19:
top, © 2011 Michael Cardinali/Courtesy of the MIT
Museum; *bottom*, Danny Kim.

CHAPTER 2
page 24: © 2011 Michael Cardinali/Courtesy of the
MIT Museum. page 26: Teague. page 27: Polaroid
Corporation Collection. Baker Library Historical
Collections. Harvard Business School. page 28:
© Bettmann/CORBIS. page 33: Danny Kim.
page 36: Courtesy of Anne Bowerman.

CHAPTER 3
page 43: Danny Kim. pages 46–47: Courtesy of
the estate of Leslie Charteris. page 49: © 2011 The
Ansel Adams Publishing Rights Trust. page 51:
Nan Lane Rudolph.

CHAPTER 4
page 52: The J. Paul Getty Museum, Los Angeles;
Polacolor 4x5 print. Courtesy of Marie Cosindas.
page 57: Courtesy of the MIT Museum. page 58:
Fritz Goro/Time & Life Pictures/Getty Images.
page 60: *top* and *left*, Courtesy of Marie Cosindas;
bottom, Nan Lane Rudolph. page 64: Bert Stern.
page 67: Danny Kim. page 69: © William Anastasi.
Copy photograph © The Metropolitan Museum
of Art/Art Resource, New York. page 70: © 2011
The Ansel Adams Publishing Rights Trust
page 72: Robert Mapplethorpe, *Self-Portrait,
1974* © Copyright The Robert Mapplethorpe
Foundation. Courtesy Art + Commerce.

page 74: Danny Kim. page 77: Bill Warriner.
page 78: Photograph by courtesy the artist and
The Pace Gallery © Chuck Close, Courtesy
The Pace Gallery. page 81: Andy Warhol, *Liza
Minnelli*, 1977. © Copyright 2012 The Andy Warhol
Foundation for the Visual Arts, Inc./Artists Rights
Society, New York. page 83: Mark Sink. page 85:
Christophe Madamour.

CHAPTER 5
page 86: David Hockney, *Sun on the Pool Los
Angeles April 13th 1982*, composite Polaroid,
24 ¾ by 36 ¼. © David Hockney. Photo credit:
Richard Schmidt. page 89: © Mark S. Dionne.
page 91: Cooper-Hewitt, National Design
Museum, Smithsonian Institution/Art Resource,
New York. page 92: Danny Kim. pages 96, 97:
Lucas Samaras, *Photo-Transformation*, June 21,
1974, photograph by Ellen Page Wilson, courtesy
The Pace Gallery; *Photo-Transformation*,
June 13, 1974, photograph by Ellen Page Wilson,
Courtesy the Pace Gallery; *Photo-Transformation*,
June 13, 1974, photograph by Ellen Labenski,
courtesy The Pace Gallery; *Photo-Transformation*,
June 13, 1974, photograph by Ellen Labenski,
courtesy The Pace Gallery. All four images © Lucas
Samaras, courtesy The Pace Gallery. page 99:
© 1978 David Byrne. page 100: André Kertész,
July 3, 1979. Estate of André Kertész/Higher
Pictures. page 103: © 2011 Eames Office, LLC
(www.eamesoffice.com). page 107: Ted Voss.
page 109: © Roger Ressmeyer/CORBIS.

CHAPTER 6
page 114: *left*, Danny Kim; *top*, Ted Voss; *bottom*,
Ted Voss. pages 116, 118: Ted Voss. page 119:
© 2011 Eames Office, LLC (www.eamesoffice.com).

CHAPTER 7
page 122: Danny Kim. page 125: © 2011 Michael
Cardinali/Courtesy of the MIT Museum.

CHAPTER 8
page 134: Copyright © David Levinthal.
page 137: Ted Voss. pages 143, 144: Copyright
2010 by Gus Van Sant. page 148: Patrick Nagatani;
image courtesy of the WestLicht Collection.
page 151: Enrique Valdivia. page 153: Jamie
Livingston. page 157: Steven Monteau.

CHAPTER 9
page 158: *Monkey With Orange*, 1980. Courtesy
of Rosamond W. Purcell. page 161: Jessie Barber.
page 162: © 2011 Christopher Bonanos. page 167:
Zora Strangefields/The Impossible Project.
page 171: Bradley Laurent/The Impossible Project.
page 174: Polaroid. page 176: Danny Kim.
page 187: John Reuter.

INDEX